Treasures of the

MUSÉE PICASSO
Paris

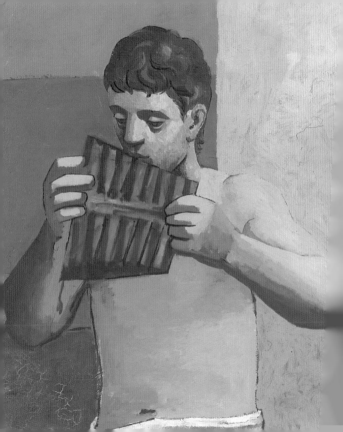

Treasures of the

MUSÉE PICASSO
Paris

Gérard Régnier

A TINY FOLIO™
Abbeville Press Publishers
New York London Paris

Front cover: *Detail of Portrait of Marie-Thérèse,* January 6, 1937. See page 93.

Back cover: *Self-Portrait,* late 1901. See page 22.

Spine: *Head of a Woman,* 1931, Boisgeloup. See page 173.

Frontispiece: Detail of *The Pipes of Pan,* summer 1923. See page 64.

Page 6: Interior of the Musée Picasso.

Page 15: Exterior of the Musée Picasso.

Page 16: Detail of *Paulo as Harlequin,* 1924. See page 65.

Page 126: Detail of *Glass, Pipe, Ace of Clubs, and Die,* summer 1914. See page 140.

Page 148: *The Jester,* 1905, Paris. Bronze, 16⅜ x 14⅝ x 9 in. (41.5 x 37 x 22.8 cm).

Page 194: *Vase: Woman with a Mantilla,* [1949], Vallauris. Thrown and modeled white clay, decorated with slip, 18⅛ x 4⅞ x 3⅜ in. (47 x 12.5 x 9.5 cm).

Page 198: *At School: Lola, the Artist's Sister,* 1895, La Coruña, Spain. Pen and black ink on paper, 9 x 5⅞ in. (22.9 x 15.1 cm).

Page 272: Detail of Henri Matisse, *Still Life with Oranges,* 1912. See page 301.

A Note about the Captions

The dates and places of execution given in brackets are not explicitly documented and have been established according to stylistic study. Locations are in France, unless otherwise indicated.

For copyright and Cataloging-in-Publication Data, see page 319.

CONTENTS

Introduction 7

PAINTINGS 17

PAPIERS COLLÉS AND RELIEF PAINTINGS 127

SCULPTURES 149

CERAMICS 195

DRAWINGS AND WATERCOLORS 199

PICASSO'S PERSONAL COLLECTION 273

Index of Illustrations 313

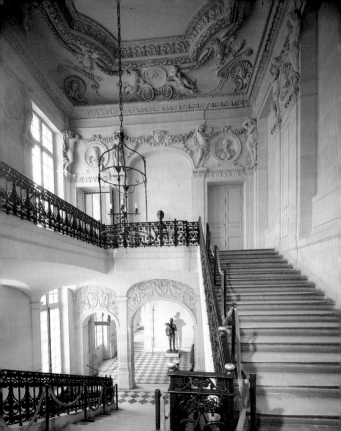

INTRODUCTION

"In truth, what is a painter? A collector who
wants to gather a collection by painting himself
the pictures he likes in the work of others."

Pablo Picasso,
interview with D. H. Kahnweiler,
February 13, 1934

Official recognition of Picasso's work was by no means
early in France: by the end of World War II, the artist
was represented by only three paintings in French public
collections. In 1947 Picasso donated ten canvases to the
newly founded Musée National d'Art Moderne in Paris,
and he displayed the same generosity toward other muse-
ums, both elsewhere in France and abroad.

His representation in France expanded dramatically
after the Bequest Act of December 31, 1968 (conceived
by André Malraux), established the concept of *dation,*
which allowed an artist's heirs to pay their estate taxes
with works of art. The first *dation* of Picasso's work
took place in 1979, six years after his death. Through
this bequest, the French State acquired 203 paintings,

158 sculptures, 16 *papiers collés* (pasted-paper collages), 29 relief paintings, 88 ceramics, more than 3,000 drawings and prints, 32 sketchbooks, illustrated books, manuscripts, and part of the primitive art collection in the painter's studio. This was complemented by the Picasso donation of 1973, which included works from the artist's personal collection and was first exhibited at the Louvre in 1978.

The purpose of the Musée Picasso, which opened at the Hôtel Salé in 1979, is to showcase "Picasso's Picassos," the personal collection of his own work that he had kept throughout his life. Such works form an inseparable ensemble, including milestone pieces that Picasso would not sell—*Still Life with Chair Caning* (page 38), *The Pipes of Pan* (page 64)—as well as sentimental or even secret works. "According to legend, Picasso kept everything," said Dominique Bozo, the museum's first director.

Displaying the collection that Picasso had kept to himself for so long reveals a profound aspect of the artist-collector's work: its strongly autobiographical tendency. He avoided the perils of narcissism precisely because of the prodigious diversity of "his art or rather *his arts*," according to Michel Leiris, who also wrote that "a series of civilizations unfolds in his work." Let us imagine that in a future century, diverse works by Picasso are found by someone with no knowledge of the artist: how could any-

one believe that their signature belonged to one single individual?

Picasso, through all his metamorphoses, always painted like Picasso, whatever technique he used. To establish boundaries between his various areas of interest or to isolate his painted work from his sculpture would be pointless, given the tremendous diversity of his art within each medium. Further, since practically no work was left unfinished in his studio, and because each work is unique, understanding his analytical approach requires a knowledge of all aspects of his work.

Revolutionary new ideas in Picasso's work always germinated out of previous works that had been dormant until a subsequent explosion. For example, his 1954 portrait of Jacqueline (page 113) captures her resemblance to one of the figures in *The Women of Algiers* by Eugène Delacroix—a subject that had long obsessed Picasso; in fact, the reinterpretation of Delacroix's work had signaled the end of Picasso's blockage during his troubled 1935–36 period. "Picasso kept all these paintings and sculptures on display as an active backdrop to his daily life, as if they were found objects, provocative and necessary, awaiting observation and the creation of complementary works," wrote Dominique Bozo. The art of scavenging and assemblage, exemplified in many sculptures such as *Head of a Bull* (page 180), is the final step in this logic.

The organizers of the museum wanted to avoid any dispersion of works that would disrupt the continuity of Picasso's oeuvre; the heirs consented to give the State the first choice of works from his estate, so that the selection would be comprehensive. In addition, some other pieces have been distributed to various French museums. As a result, French collections of Picasso's work now complement each other amazingly well, and they in turn are complemented by the Museo Picasso in Barcelona. But the Musée Picasso remains the artist's "studio," and, as Roland Penrose once said, an "alchemist's laboratory would look dull in comparison."

Following the death of the painter's last wife, Jacqueline, a second *dation* took place in 1990. This time the choice was made to strengthen the collection by adding forty-seven paintings, two sculptures, about forty drawings, twenty-four sketchbooks, nineteen ceramics, two hundred forty-five prints and lithographs, and one *papier collé* by Georges Braque. The museum's imposing gallery of portraits reaches its zenith with the 1954 *Jacqueline with Crossed Hands* (page 113). The twenty-four sketchbooks (six of which had been previously unknown) comprise eleven hundred leaves, allowing one to retrace a creative process as it developed over the course of eighty years. Some pieces from this second *dation* were deposited in twenty-one museums outside

Paris, as well as at the Musée National d'Art Moderne, the Department of Prints of the Bibliothèque Nationale, and the Musée de Sèvres—all in Paris.

In addition, the Musée National d'Art Moderne made a long-term loan to the Musée Picasso of *Portrait of Gustave Coquiot;* a large gouache, *Three Dutch Girls;* and some pieces given to the State by Michel and Louise Leiris in 1984, including the 1914 sculpture *Glass of Absinthe* and the 1955 portrait *Jacqueline in Turkish Costume.* The Musée Picasso has also received bequests from individuals, such as *Three Figures under a Tree* of 1906–7, donated in 1986 by the heir of Douglas Cooper, and among the manuscripts, Picasso's 1915 letter to André Salmon (page 240). It also purchased some pieces, such as *Composition with Butterfly* of 1932 (page 147), so beloved by the Surrealist André Breton, and *Portrait of Apollinaire with Bandaged Head* (page 244), formerly in the poet's estate. D. H. Kahnweiler bequeathed *Still Life with a Razor Strop* of 1909. *Celestina* (page 24), a major milestone of the Blue Period, was added to the museum's collection in 1990, as a result of negotiations with the collector Fredrik Roos.

The Musée Picasso thus displays an abundance of works; the few missing aspects of the artist's career are represented by allusion or by substitution. For example, since the museum does not own any large Cubist

compositions, it retraces the stages of Cubism by using smaller works and drawings combined with collages, such as the famous *Still Life with Chair Caning* (page 38). Generally speaking, the paintings of the Blue and Rose periods are not well represented but works from the 1920s and 1930s abound, and the second *dation* balanced the collection through a massive representation of paintings from the latter period.

The *papiers collés* and the constructions are the true strength of the museum for the Cubist period of 1912–15. The same is true for the relief paintings: the museum has the most complete collection of this type of object, missing pieces only from 1937–38. Picasso kept all of his sculptures, and thus their importance within his oeuvre has been acknowledged only recently. The museum's collection is unequaled: it owns practically all of the artist's unique pieces. The 1907 *Head of a Man* (page 154), from the second *dation,* allowed the completion of the period immediately preceding Cubism. As for ceramics, all eighty-eight pieces of the first *dation* are unique.

Finally, the drawings at the Musée Picasso form an exceptional ensemble (with a few gaps in the period after 1956): these are the works par excellence with which the artist never parted. Once again, the curators decided to "retain the large compositions and not to break up the

ensembles," according to Dominique Bozo. Of his printed work, Picasso had kept all the single prints and all the prints published in limited editions. The museum owns the preparatory states, the engraved copper plates and all the final plates for the *Vollard Series* (donated by Roger and Madeleine Lacourière) and the model for *Song of the Dead* by Pierre Reverdy. The second *dation,* notably, brought in two sketchbooks for *Les Demoiselles d'Avignon* and a number of studies for *Three Women*.

The magic of the Musée Picasso also stems from the silent dialogue between the work and the place—the Hôtel Salé, one of the most beautiful townhouses in the Marais section of Paris. Each enhances the other through subtle correspondences—appropriately, since Picasso had always lived in old houses. The Hôtel Salé was built in 1656–59 for Pierre Aubert, a salt-tax collector (hence the building's nickname, Hôtel Salé or "salted house"). In its current state, beautifully renovated by the architect Roland Simounet, it offers a multitude of different period styles. The magnificent central staircase was decorated by Gaspard and Balthasar Marsy, brothers who also worked at Versailles, and by Martin Desjardins. Later, when the building was chosen to house the Picasso collection, Diego Giacometti was commissioned to complete part of the decoration, including the chandeliers and the furnishing of the galleries.

The architecture has dictated the itinerary inside the museum—at times chronological, at other times thematic, with the garden used to display a few sculptures. The result is that the Hôtel Salé has become a museum fit for what Gaëton Picon called "the Picasso civilization, that Louvre from another planet."

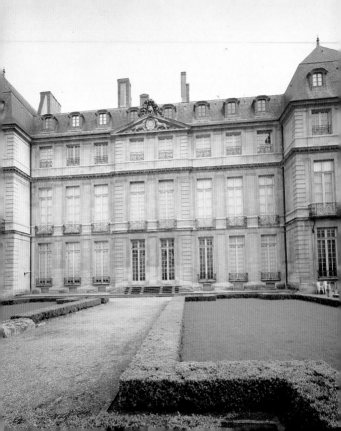

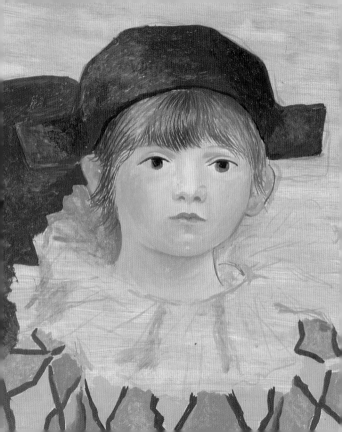

PAINTINGS

The first work on our itinerary is the 1901 *Self-Portrait* (page 22). It symbolizes the Blue Period, whose inaugural work was *The Death of Casagemas* (page 21). In 1906, at Gosol, Picasso achieved an independent style, in which volume reappeared. Beginning in 1907, with *Les Demoiselles d'Avignon,* the artist attempted to suggest volume without making use of chiaroscuro. Figurative elements were fragmented and flattened in a space no longer organized according to illusionistic perspective.

1909–17: Cubism. How to "objectively" render a three-dimensional object on a two-dimensional canvas without using the old conventions? *Man with a Guitar* (page 37) symbolizes Analytic Cubism—the first, or "hermetic," phase of 1910–11. In the second, or Synthetic, phase Picasso introduced a real piece of oilcloth into *Still Life with Chair Caning* (page 38), intending both to put into play and to call into question a mode of representation. These paintings imitate his *papiers collés.*

Though fully Cubist, *The Painter and His Model* (page 44) seems to anticipate the 1918–24 period, which was characterized by a Neoclassical style that is equally an anthology of Cubism and of Picasso's great activity for

the theater. It has been described by Pierre Daix as a "snared Classicism," glorifying aesthetic rereadings (as in *The Happy Family, after Le Nain,* page 47), and his recurring theme of the gigantic woman. *Reading the Letter* (page 57) is a novel work whose meaning escapes us, probably referring to Georges Braque and Guillaume Apollinaire.

From 1925 on, Picasso dared everything. His ambiguous relationship with Surrealism, leading to the appearance of Freudian subjects in his work, was accompanied by a strong return to his Expressionist tendencies. In 1927–28 Picasso painted his series of Bathers in Dinard. In 1928 the Minotaur appeared in his work for the first time, summing up almost all of Picasso's themes. In *The Crucifixion* (page 78), his favorite subject because of its endless repetition in the history of art, Picasso combined memories of the bullfight with autobiographical elements.

Between May 1935 and February 1936 Picasso stopped painting. His inspiration for the works that followed was even more diverse, inspired by his two muses, Marie-Thérèse and Dora Maar (*Weeping Woman,* page 98). Later, war pervaded his production, infusing even his nonpolitical works. Starting in 1954, inspired by Jacqueline, the artist multiplied his homages to the masters of the past. In his cycle of *Luncheon on the Grass*—

27 paintings (pages 116, 117) and 140 drawings—Picasso challenged Edouard Manet, with an aggressive attitude that Manet himself had not adopted vis-à-vis his own venerable sources.

The last period began in the 1960s. This work, still disturbing and still an influence on the contemporary avant-garde, looks like a diary scrawled by the artist. The Hispanic aspect of his work seems to be magnified in a world of "tarot" (as André Malraux called it) that distills the entire legacy of painting, from Fayoum, or Egyptian funerary portraits, to those of the Renaissance. Old subjects were treated with any means at hand, as in *Seated Old Man* (page 122), which sums up different representations of famous paintings. At the end of his life Picasso declared: "Painting has still to be painted."

The Barefoot Girl, early 1895, La Coruña, Spain.
Oil on canvas, 29½ x 19⅝ in. (75 x 50 cm).

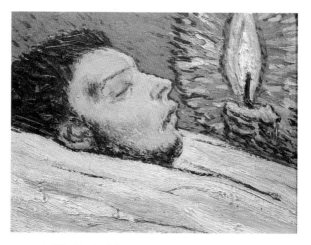

The Death of Casagemas, summer 1901, Paris.
Oil on panel, 10⅝ x 13⅝ in. (27 x 35 cm).

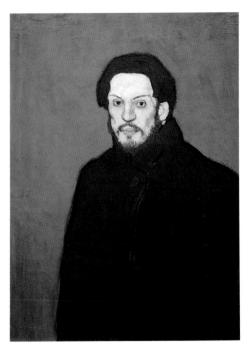

Self-Portrait, late 1901, Paris.
Oil on canvas, 31¾ x 23⅝ in. (81 x 60 cm).

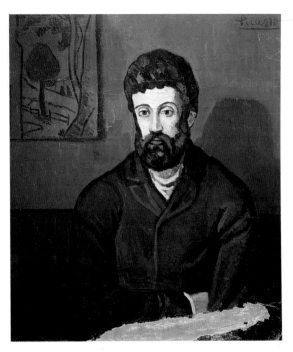

Portrait of a Man, winter 1902–3, Paris–Barcelona.
Oil on canvas, 36⅝ x 30⅝ in. (93 x 78 cm).

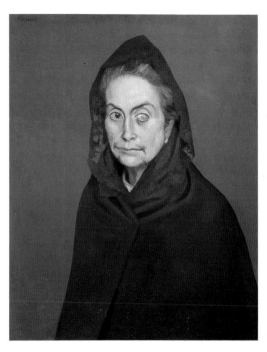

Celestina, 1904, Barcelona.
Oil on canvas, 27½ x 22 in. (70 x 56 cm).

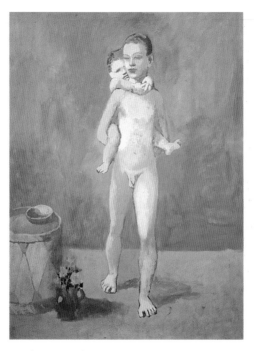

The Two Brothers, summer 1906, Gosol, Spain.
Gouache on cardboard, 31⅜ x 23¼ in. (80 x 59 cm).

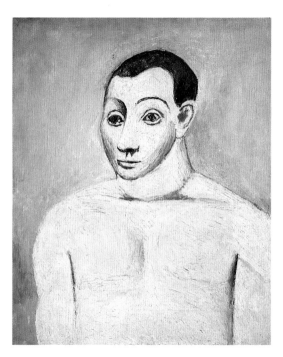

Self-Portrait, fall 1906, Paris.
Oil on canvas, 25⅝ x 21⅜ in. (65 x 54 cm).

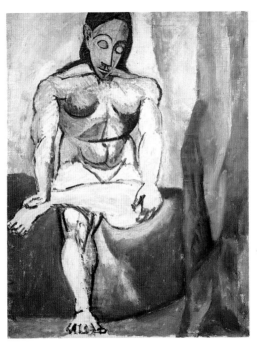

Seated Nude (study for *Les Demoiselles d'Avignon*),
[winter 1906–7], Paris.
Oil on canvas, 47⅝ x 36¾ in. (121 x 93.5 cm).

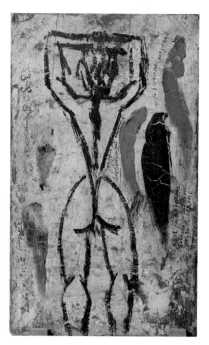

Small Nude from the Back with Raised Arms
(study for *Les Demoiselles d'Avignon*), May 1907, Paris.
Oil on panel, 7½ x 4½ in. (19.1 x 11.5 cm).

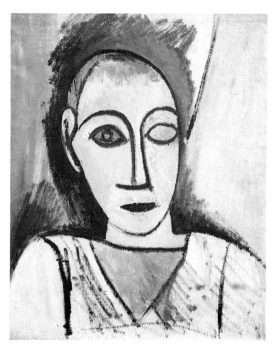

Bust of a Man
(study for *Les Demoiselles d'Avignon*), spring 1907, Paris.
Oil on canvas, 22 x 18¼ in. (56 x 46.5 cm).

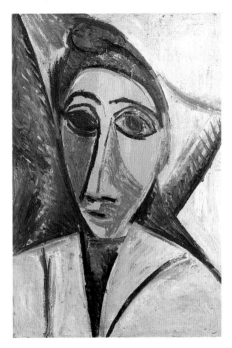

Bust of a Woman or a Sailor
(study for *Les Demoiselles d'Avignon*), spring 1907, Paris.
Oil on cardboard, 21 x 14¼ in. (53.5 x 36.2 cm).

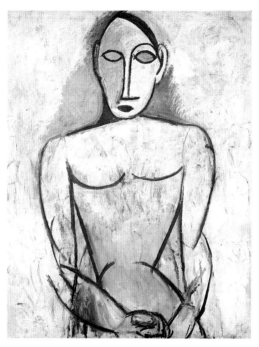

Woman with Joined Hands
(study for *Les Demoiselles d'Avignon*), spring 1907, Paris.
Oil on canvas, 35⅝ x 28⅛ in. (90.5 x 71.5 cm).

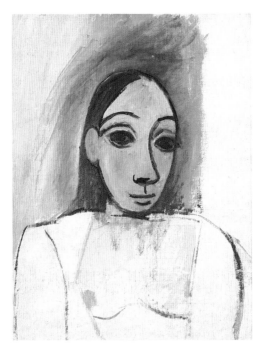

Bust of a Woman
(study for *Les Demoiselles d'Avignon*), spring 1907, Paris.
Oil on canvas, 23 x 18⅜ in. (58.5 x 46.5 cm).

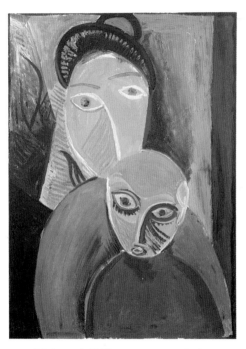

Mother and Child, summer 1907, Paris.
Oil on canvas, 31¾ x 23⅝ in. (81 x 60 cm).

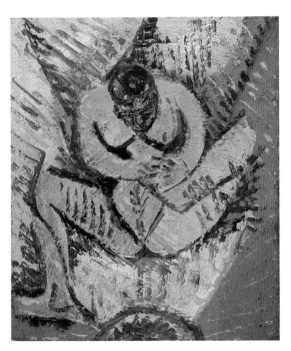

Small Seated Nude, summer 1907, Paris.
Oil on panel, 6⅞ x 5⅞ in. (17.6 x 15 cm).

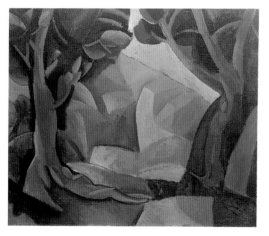

Landscape with Two Figures, fall 1908, [Paris].
Oil on canvas, 23⅝ x 28⅝ in. (60 x 73 cm)

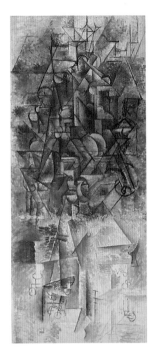

Man with a Mandolin, fall 1911, Paris.
Oil on canvas, 63⅝ x 27⅞ in. (162 x 71 cm).

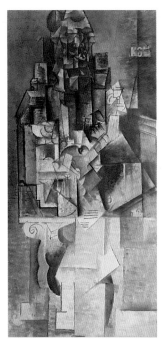

Man with a Guitar, fall 1911[–13], Paris.
Oil on canvas, 60⅝ x 30½ in. (154 x 77.5 cm).

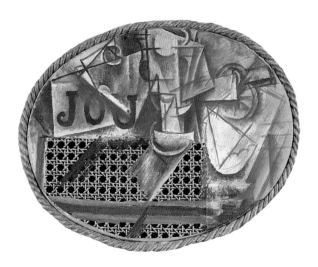

Still Life with Chair Caning, spring 1912, Paris.
Oil and oilcloth on canvas framed with rope,
11⅜ x 14½ in. (29 x 37 cm).

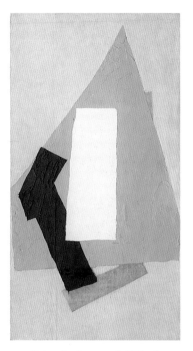

Guitar, [spring 1913], [Céret].
Oil on canvas pasted on panel,
34¼ x 18⅝ in. (87 x 47.5 cm).

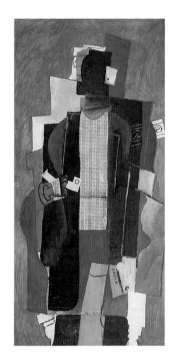

Man with a Pipe, [spring 1914], [Paris].
Oil and printed fabric pasted on canvas,
54⅜ x 26¼ in. (138 x 66.5 cm).

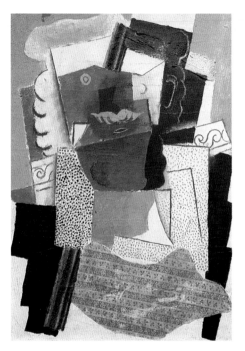

Man with a Mustache, [spring 1914], [Paris].
Oil and printed fabric pasted on canvas,
25¾ x 18⅜ in. (65.5 x 46.6 cm).

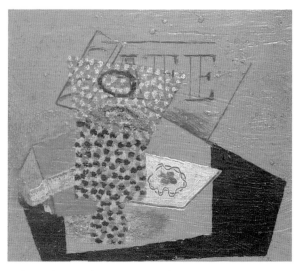

Glass, Tobacco Pack, and Ace of Clubs, summer 1914, Avignon.
Oil, pencil, and sand on panel, 5⅞ x 6⅞ in. (15 x 17.7 cm).

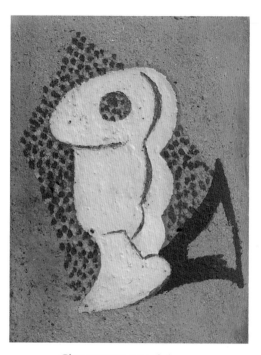

Glass, summer 1914, Avignon.
Oil and sand on panel,
6⅞ x 5⅜ x ⅛ in. (17.6 x 13.4 x .3 cm).

The Painter and His Model, summer 1914, Avignon.
Oil and pencil on canvas, 22¾ x 22 in. (58 x 55.9 cm).

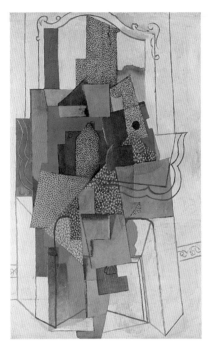

Man before a Fireplace, 1916, Paris.
Oil on canvas, 51¼ x 31⅞ in. (130 x 81 cm).

Portrait of Olga in an Armchair, fall 1917, Montrouge.
Oil on canvas, 51¼ x 34⅞ in. (130 x 88.8 cm).

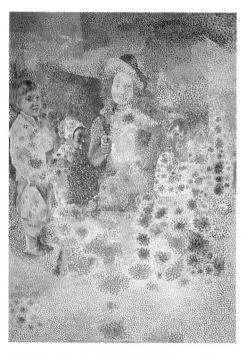

The Happy Family, after Le Nain, fall 1917, [Paris].
Oil on canvas, 63⅝ x 46½ in. (162 x 118 cm).

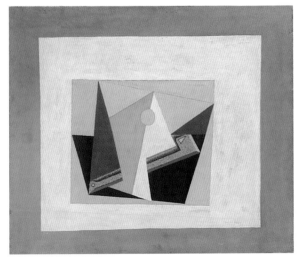

Glass and Pipe, 1918, [Paris].
Oil and sand on canvas, 18 x 21⅝ in. (45.7 x 55 cm).

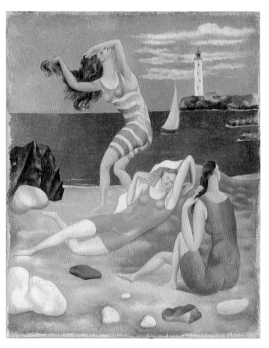

Bathers, summer 1918, Biarritz.
Oil on canvas, 10⅝ x 8⅝ in. (27 x 22 cm).

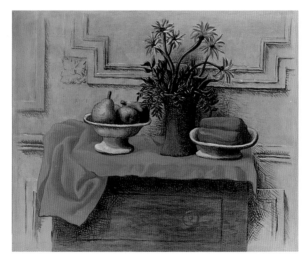

Still Life on a Chest, 1919, [Paris].
Oil on canvas, 31⅞ x 39⅜ in. (81 x 100 cm).

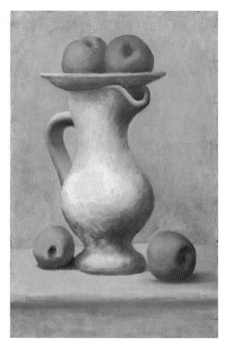

Still Life with Pitcher and Apples, 1919.
Oil on canvas, 25⅝ x 16⅞ in. (65 x 43 cm).

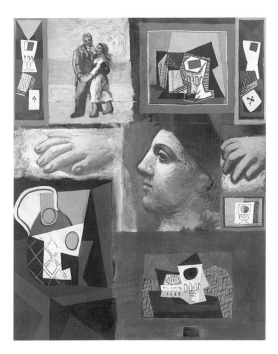

Studies, 1920.
Oil on canvas, 39⅜ x 31⅞ in. (100 x 81 cm).

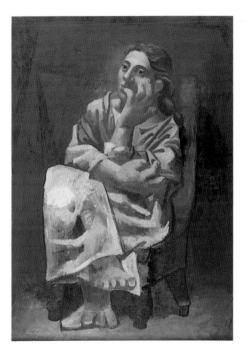

Seated Woman, 1920, Paris.
Oil on canvas, 36¼ x 25⅝ in. (92 x 65 cm).

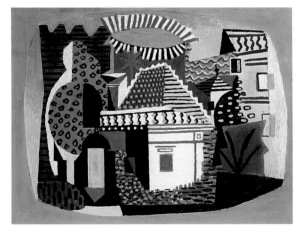

Landscape at Juan-les-Pins, summer 1920, Juan-les-Pins.
Oil on canvas, 20½ x 27⅝ in. (52 x 70 cm).

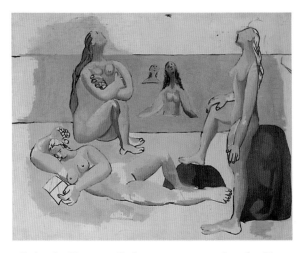

Bathers Looking at an Airplane, summer 1920, Juan-les-Pins.
Oil on plywood, 28⅞ x 36⅜ in. (73.5 x 92.5 cm).

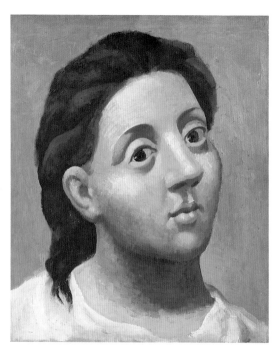

Woman's Head, 1921, [Paris].
Oil on canvas, 21⅝ x 18⅛ in. (55 x 46 cm).

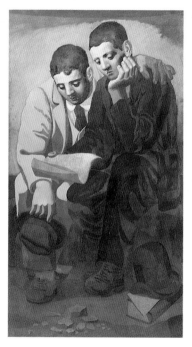

Reading the Letter, 1921, [Paris].
Oil on canvas, 72⅜ x 41⅜ in. (184 x 105 cm).

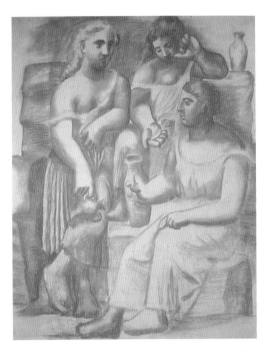

Three Women at the Spring, summer 1921, Fontainebleau.
Red chalk on canvas, 78⅝ x 63⅜ in. (200 x 161 cm).

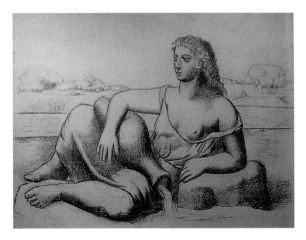

The Spring, summer 1921, Fontainebleau.
Crayon on canvas, 39⅜ x 78⅝ in. (100 x 200 cm).

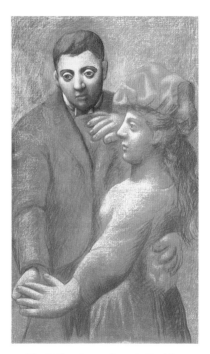

The Village Dance, [1922], [Paris].
Pastel and oil on canvas,
54⅞ x 33⅝ in. (139.5 x 85.5 cm).

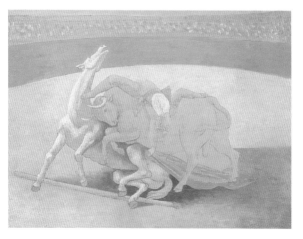

Bullfight, [1922].
Oil and pencil on panel,
5⅜ x 7½ in. (13.6 x 19 cm).

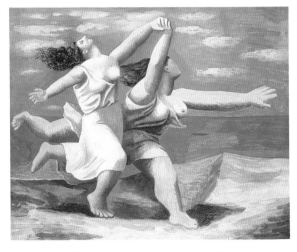

Two Women Running on the Beach, or *The Race,*
summer 1922, Dinard. Gouache on plywood,
12¾ x 16⅛ in. (32.5 x 41.1 cm).

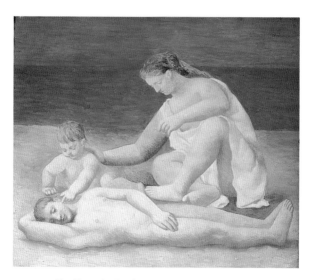

Family at the Seashore, summer 1922, Dinard.
Oil on panel, 6⅞ x 8 in. (17.6 x 20.2 cm).

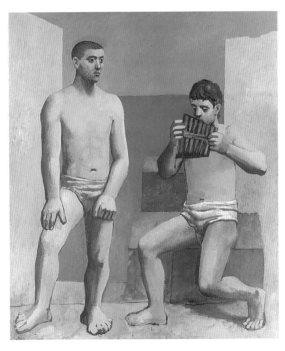

The Pipes of Pan, summer 1923, Antibes.
Oil on canvas, 80¾ x 68½ in. (205 x 174 cm).

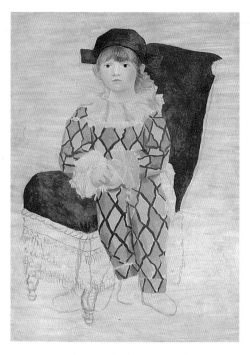

Paulo as Harlequin, 1924, Paris.
Oil on canvas, 51¼ x 38⅜ in. (130 x 97.5 cm).

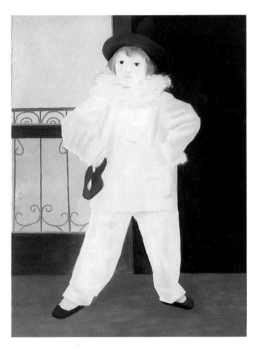

Paulo as Pierrot, February 28, 1925, Paris.
Oil on canvas, 51¼ x 38¼ in. (130 x 97 cm).

The Kiss, summer 1925, Juan-les-Pins.
Oil on canvas, 51⅜ x 38½ in. (130.5 x 97.7 cm).

The Painter and His Model, 1926, [Paris].
Oil on canvas, 67⅝ x 100¾ in. (172 x 256 cm).

Bather, August 6, 1928, Dinard.
Oil on canvas, 8⅝ x 5½ in. (22 x 14 cm).

Bather Opening a Bathing Cabin, August 9, 1928, Dinard.
Oil on canvas, 12⅞ x 8⅝ in. (32.8 x 22 cm).

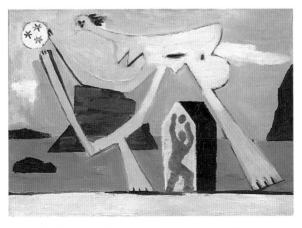

Ball Players on the Beach, August 15, 1928, Dinard.
Oil on canvas, 9⅜ x 13⅝ in. (24 x 34.9 cm).

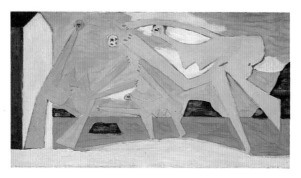

Bathers Playing Ball, August 20, 1928, Dinard.
Oil on canvas, 8½ x 16¼ in. (21.7 x 41.2 cm).

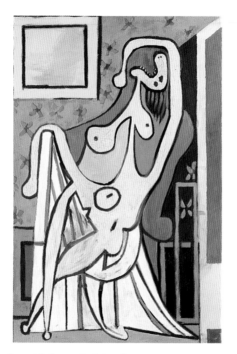

Large Nude in a Red Armchair, May 5, 1929, Paris.
Oil on canvas, 76¾ x 50¾ in. (195 x 129 cm).

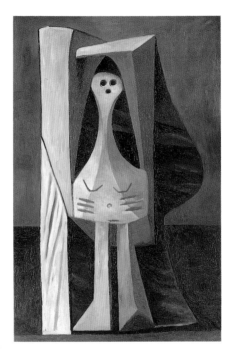

Large Bather, May 26, 1929, Paris.
Oil on canvas, 76¾ x 51¼ in. (195 x 130 cm).

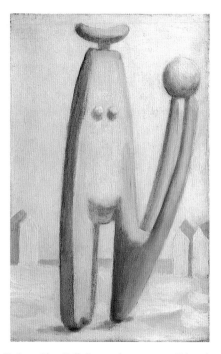

Bather with a Ball, September 1, 1929, Dinard.
Oil on canvas, 8⅝ x 5½ in. (21.9 x 14 cm).

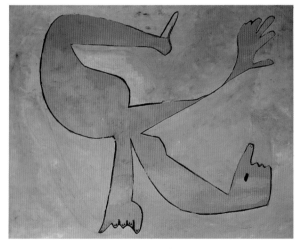

The Swimmer, November 1929, Paris.
Oil on canvas, 51¼ x 63¾ in. (130 x 162 cm).

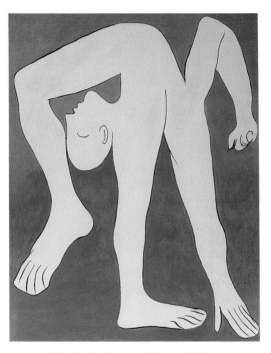

The Acrobat, January 18, 1930, Paris.
Oil on canvas, 63¾ x 51¼ in. (162 x 130 cm).

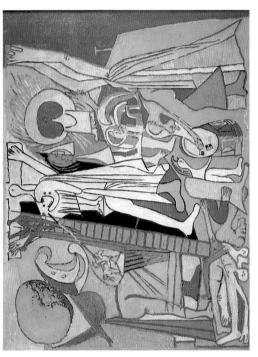

The Crucifixion, February 7, 1930, Paris.
Oil on plywood, 20⅜ x 26¼ in. (51.5 x 66.5 cm).

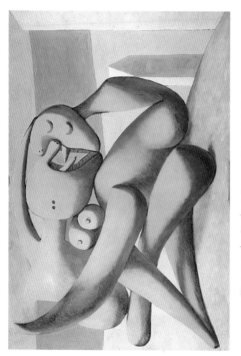

Figures at the Seashore, January 12, 1931, Paris. Oil on canvas, 51¼ x 76¾ in. (130 x 195 cm).

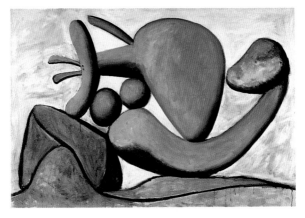

Woman Throwing a Stone, March 8, 1931, Paris.
Oil on canvas, 51⅜ x 77 in. (130.5 x 195.5 cm).

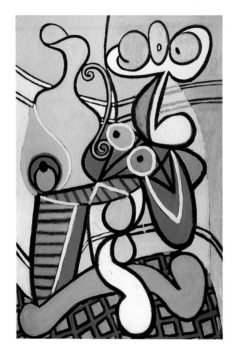

Large Still Life on a Pedestal Table, March 11, 1931, Paris.
Oil on canvas, 76¾ x 51⅜ in. (195 x 130.5 cm).

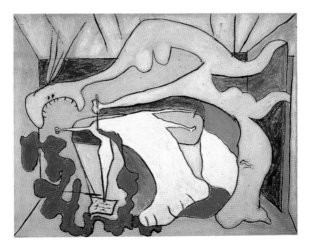

Woman with Stiletto, or *The Death of Marat,*
December 19–25, 1931, [Paris].
Oil on canvas, 18⅜ x 24¼ in. (46.5 x 61.5 cm).

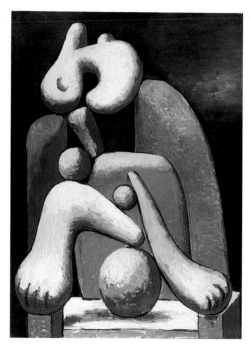

Woman in a Red Armchair, January 27, 1932, Boisgeloup.
Oil on canvas, 51⅜ x 38¼ in. (130.2 x 97 cm).

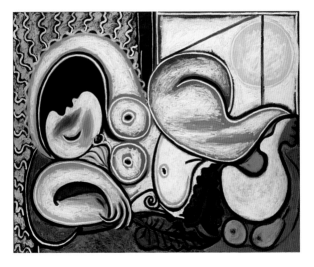

Sleeping Nude, April 4, 1932, Boisgeloup.
Oil on canvas, 51¼ x 63⅝ in. (130 x 161.7 cm).

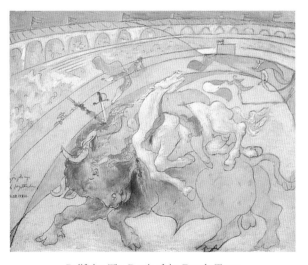

Bullfight: The Death of the Female Torero,
September 6, 1933, Boisgeloup.
Oil and pencil on panel, 8½ x 10⅝ in. (21.7 x 27 cm).

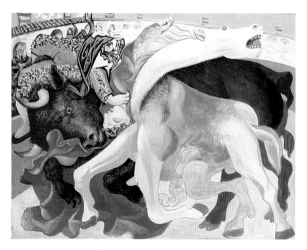

Bullfight: The Death of the Torero,
September 19, 1933, Boisgeloup.
Oil on panel, 12¼ x 15⅝ in. (31 x 40 cm).

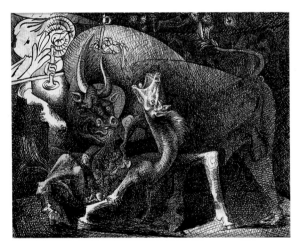

Woman with Candle, Fight Between the Bull and the Horse,
July 24, 1934, Boisgeloup. Pen and india ink, brown pencil
on canvas pasted on plywood, 12⅜ x 15⅞ in. (31.5 x 40.5 cm).

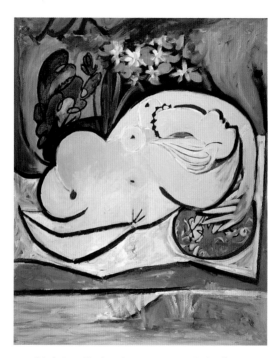

Nude in a Garden, August 4, 1934, Boisgeloup.
Oil on canvas, 63¾ x 51¼ in. (162 x 130 cm).

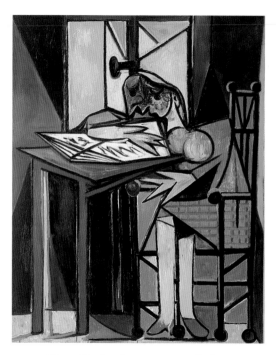

Woman Reading, January 9, 1935, Paris.
Oil on canvas, 63¾ x 44½ in. (162 x 113 cm).

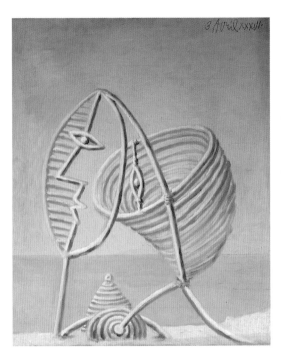

Portrait of a Young Girl, April 3, 1936, Juan-les-Pins.
Oil on canvas, 21⅞ x 18⅛ in. (55.5 x 46 cm).

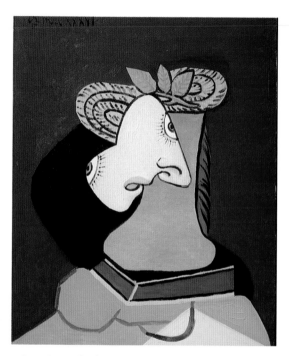

Straw Hat with Blue Leaves, May 1, 1936, Juan-les-Pins.
Oil on canvas, 24 x 19⅝ in. (61 x 50 cm).

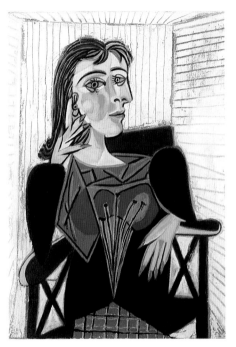

Portrait of Dora Maar, 1937, [Paris].
Oil on canvas, 36¼ x 25⅝ in. (92 x 65 cm).

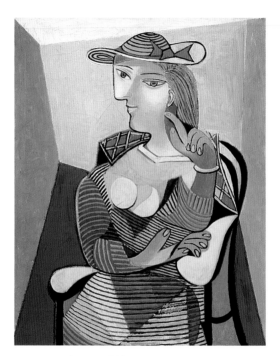

Portrait of Marie-Thérèse, January 6, 1937, [Paris].
Oil on canvas, 39⅜ x 31⅞ in. (100 x 81 cm).

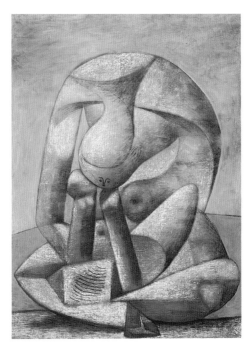

Large Bather with a Book, February 18, 1937, Paris.
Oil, pastel, and charcoal on canvas,
51¼ x 38⅜ in. (130 x 97.5 cm).

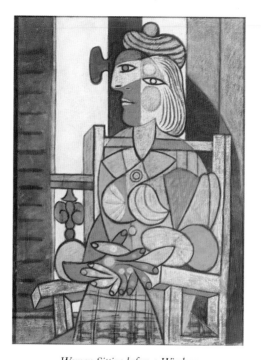

Woman Sitting before a Window,
March 11, 1937, [Le Tremblay-sur-Mauldre].
Oil and pastel on canvas, 51¼ x 38⅜ in. (130 x 97.3 cm).

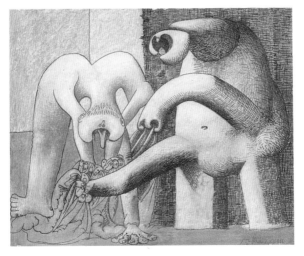

Two Nude Women on the Beach, May 1, 1937, Paris.
India ink and gouache on panel, 8⅝ x 10⅝ in. (22 x 27 cm).

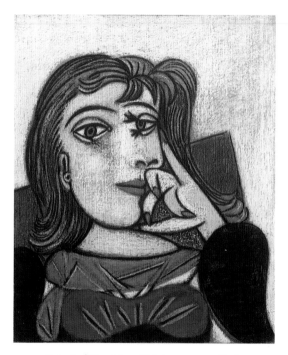

Portrait of Dora Maar, October 1, 1937, Paris.
Oil and pastel on panel, 21⅝ x 17⅞ in. (55 x 45.5 cm).

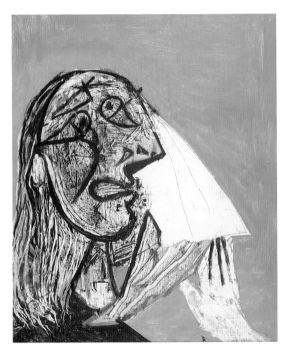

Weeping Woman, October 18, 1937, Paris.
Oil on canvas, 21¾ x 18¼ in. (55.3 x 46.3 cm).

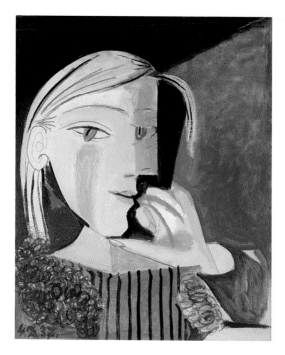

Portrait of Marie-Thérèse, December 4, 1937, Paris.
Oil and pencil on canvas, 18⅛ x 15 in. (46 x 38 cm).

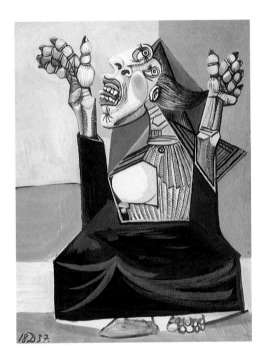

Supplicating Woman, December 18, 1937, Paris.
Gouache on panel, 9⅜ x 7⅜ in. (24 x 18.5 cm).

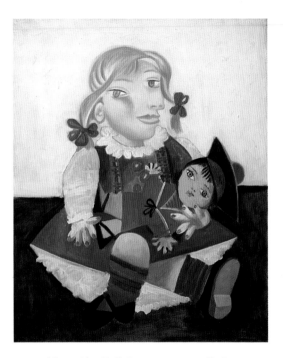

Maya with a Doll, January 16, 1938, Paris.
Oil on canvas, 28⅞ x 23⅝ in. (73.5 x 60 cm).

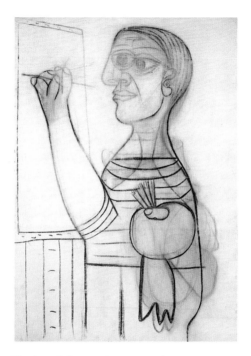

The Artist before His Canvas, March 22, 1938, Paris.
Charcoal on canvas, 51¼ x 37 in. (130 x 94 cm).

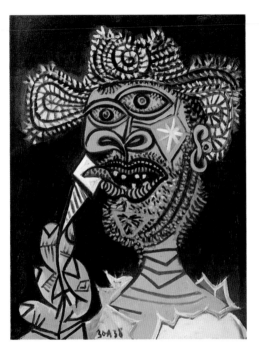

Man with a Straw Hat and Ice Cream Cone,
August 30, 1938, Mougins.
Oil on canvas, 24 x 18⅛ in. (61 x 46 cm).

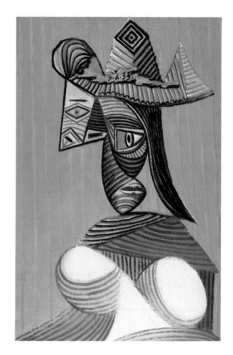

Bust of a Woman with Striped Hat, June 3, 1939, Paris.
Oil on canvas, 31⅞ x 21⅜ in. (81 x 54 cm).

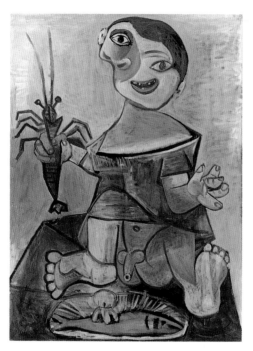

Small Boy with a Crayfish, June 21, 1941, Paris.
Oil on canvas, 51¼ x 38⅜ in. (130 x 97.3 cm).

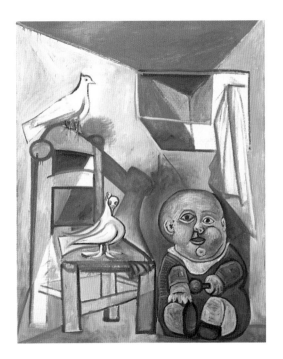

Child with Doves, August 24, 1943, Paris.
Oil on canvas, 63¾ x 51¼ in. (162 x 130 cm).

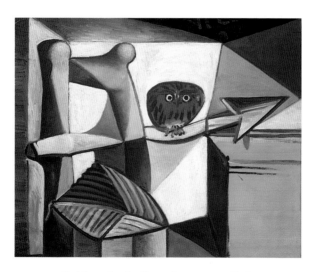

Owl in an Interior, December 7, 1946, Paris.
Oil on plywood, 31⅞ x 39⅜ in. (81 x 100 cm).

The Kitchen, November 1948, Paris.
Oil on canvas, 68⅞ x 99¼ in. (175 x 252 cm).

Pages' Games, February 24, 1951, Vallauris. Oil on panel, 21⅜ x 25⅝ in. (54 x 65 cm).

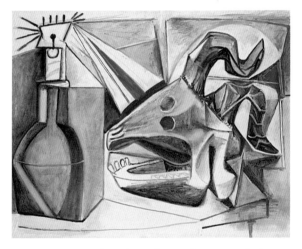

Goat's Skull, Bottle, and Candle, March 25, 1952, Paris.
Oil on canvas, 35 x 45⅝ in. (89 x 116 cm).

Child Playing with a Truck, December 27, 1953, Vallauris.
Oil on canvas, 51¼ x 38 in. (130 x 96.5 cm).

The Shadow, December 29, 1953, Vallauris.
Oil and charcoal on canvas, 51 x 38 in. (129.5 x 96.5 cm).

Jacqueline with Crossed Hands, June 3, 1954, Vallauris.
Oil on canvas, 45⅝ x 34¾ in. (116 x 88.5 cm).

The Studio at La Californie, March 30, 1956, Cannes.
Oil on canvas, 44⅞ x 57½ in. (114 x 146 cm).

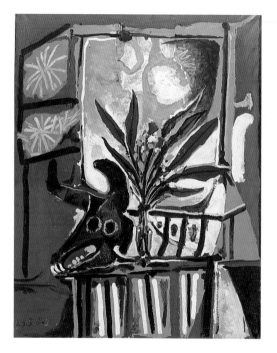

Still Life with Bull's Head, May 25–June 9, 1958, Cannes.
Oil on canvas, 64 x 51¼ in. (162.5 x 130 cm).

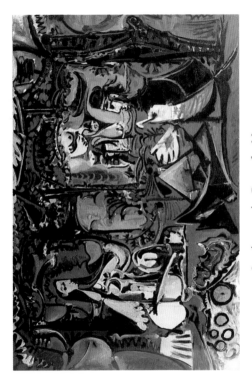

Luncheon on the Grass, after Manet,
March 3–August 20, 1960, Vauvenargues.
Oil on canvas, 51¼ x 76¾ in. (130 x 195 cm).

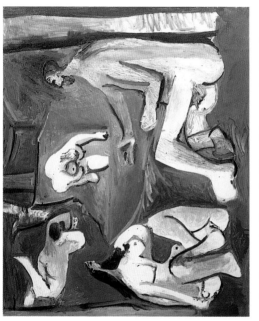

Luncheon on the Grass, after Manet, July 13, 1961, Mougins. Oil on canvas, 23⅝ x 28⅝ in. (60 x 73 cm).

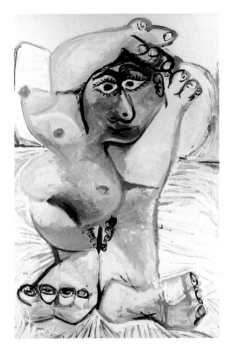

Reclining Nude, June 14, 1967, Mougins.
Oil on canvas, 76⅝ x 51¼ in. (195 x 130 cm).

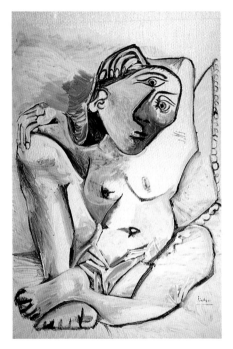

Woman with Pillow, July 10, 1969, Mougins.
Oil on canvas, 76⅜ x 51¼ in. (194 x 130 cm).

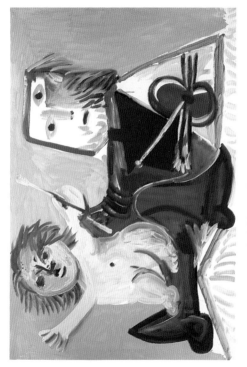

Painter and Child, October 21, 1969, Mougins.
Oil on canvas, 51¼ x 76¾ in. (130 x 195 cm).

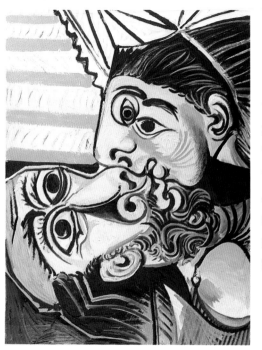

The Kiss, October 26, 1969, Mougins.
Oil on canvas, 38¼ x 51¼ in. (97 x 130 cm).

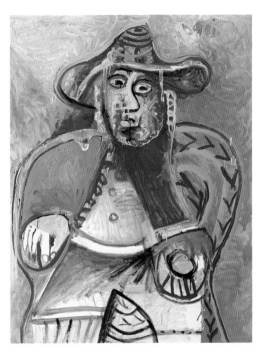

Seated Old Man,
September 26, 1970–November 14, 1971, Mougins.
Oil on canvas, 57⅜ x 44⅞ in. (145.5 x 114 cm).

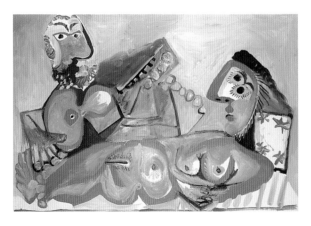

Reclining Nude and Man Playing the Guitar,
October 27, 1970, Mougins.
Oil on canvas, 51¼ x 76¾ in. (130 x 195 cm).

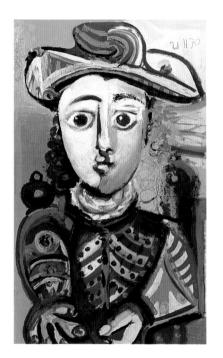

Seated Young Girl, November 21, 1970, Mougins.
Oil on plywood, 51⅜ x 31⅝ in. (130.3 x 80.3 cm).

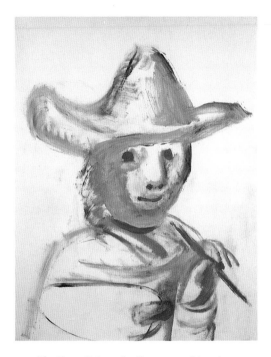

The Young Painter, April 14, 1972, Mougins.
Oil on canvas, 35¾ x 28½ in. (91 x 72.5 cm).

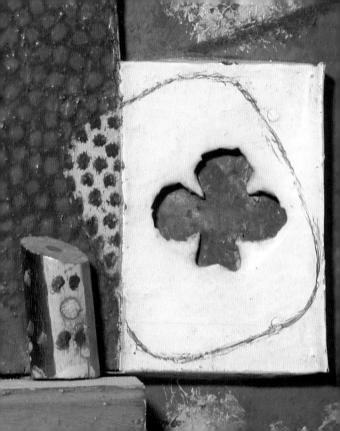

PAPIERS COLLÉS AND RELIEF PAINTINGS

This chapter represents only *papiers collés* (pasted-paper collages) in the strict sense of the term and not the museum's entire collection of collages. This process—in which the elements are often pinned rather than pasted and in which an underlying drawing can sometimes be found—was invented by Georges Braque in September 1912. Picasso soon appropriated it for himself and executed three generations of *papiers collés* during the period from 1912 to 1914, plus the later *Women Bathing,* a tapestry cartoon dated to 1938. The process became part of the logic of Synthetic Cubism, with which the artists attempted to anchor Cubism more solidly in the world.

Yet even if Cubism is a form of realism, several levels of reality coexist within it. Picasso combined real elements; drawn, cut-out, and pasted imitations of other elements; and trompe-l'oeil elements. Such was the complexity of his desire to "name things." "Nature," Picasso said, "must exist so that it can be abused." Painting reveals itself through Cubism as being based on signs, on assembly and puns, and on the "barely manual exploitation of equivalences," as Michel Leiris put it.

From 1912 to 1914, relief paintings appear as three-dimensional extensions of the *papiers collés*. Are they sculpture that's been painted or paintings in relief? Somewhere between the fictional space of painting and the real space of sculpture, they are, according to D. H. Kahnweiler, "two-dimensional backgrounds from which elements project in relief," sometimes coming very close to trompe-l'oeil.

Often the use of humble materials contrasts with an extremely sophisticated purpose. For *Glass, Pipe, Ace of Clubs, and Die* (page 140), Picasso chose a tondo—that venerable format—but used a mundane object to serve as the background of the composition. Relief defines the elements of the still life, and in his reliefs Picasso reiterated the Cubist deconstruction of an object being shown from all its sides simultaneously.

Not only does Picasso's realism require greatly nuanced analysis, but one must also examine the artist's fidelity to figurative art, which he never rejected. The motif can be imaginary without being abstract, and the artist joyfully turned his back on such categories: "There is not a figurative art and a nonfigurative art. All things take form as figures."

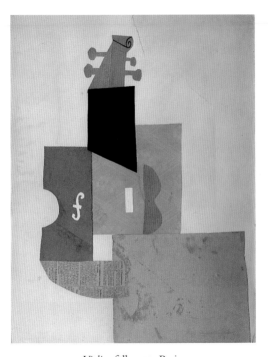

Violin, fall 1912, Paris.
Charcoal on colored paper, wallpaper, and
newspaper pasted on cardboard, 25⅝ x 19⅞ in. (65 x 50 cm).

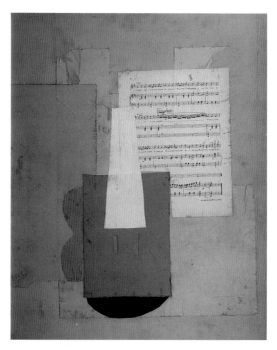

Violin and Sheet Music, fall 1912, Paris.
Gouache on colored paper and sheet music pasted
on cardboard, 30⅝ x 25 in. (78 x 63.5 cm).

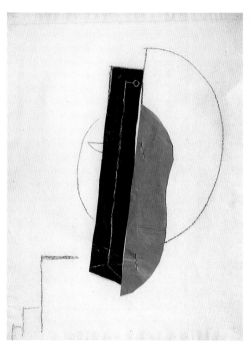

Head, early 1913, [Paris–Céret].
Pinned colored paper, charcoal, and chalk on Ingres paper,
24⅜ x 18⅜ in. (61.7 x 46.8 cm).

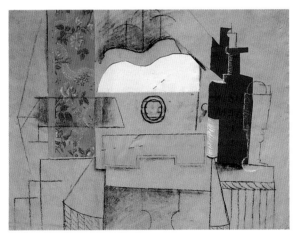

Guitar, Glass, Bottle of White Brandy, spring 1913, Céret.
Pinned colored paper, wallpaper, charcoal, and chalk
on blue Ingres paper, 18⅝ x 24⅜ in. (47.2 x 61.8 cm).

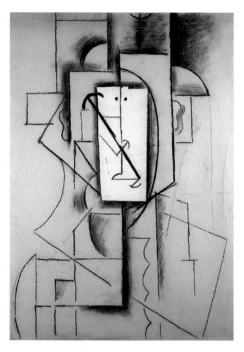

Head of Harlequin, 1913, Céret.
Pinned paper and charcoal on Ingres paper,
24⅝ x 18½ in. (62.7 x 47 cm).

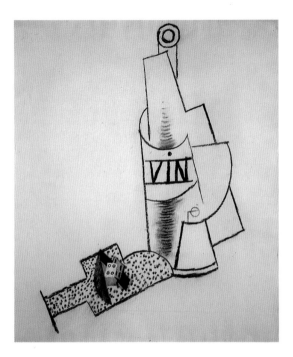

Bottle of Wine and Dice, spring 1914, Paris.
Charcoal on Ingres paper, oil, and gouache on
pinned Ingres paper, 19⅜ x 16⅞ in. (49 x 43 cm).

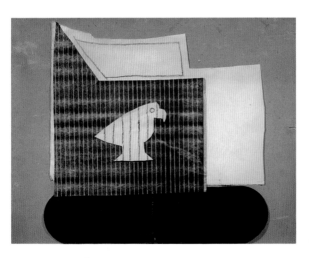

Bird in a Cage, winter 1918–19, Paris.
Pinned tarpapers and charcoal on cardboard,
16⅛ x 23¼ in. (41 x 59 cm).

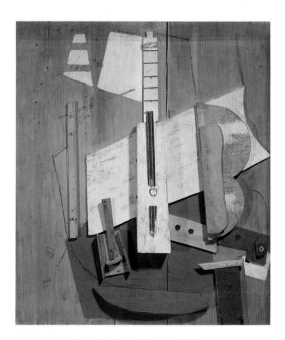

Guitar and Bottle of Bass, [spring–fall] 1913, Paris.
Painted wood, pasted paper, charcoal, and nails on
wooden support, 35¼ x 31⅜ x 5½ in. (89.5 x 80 x 14 cm).

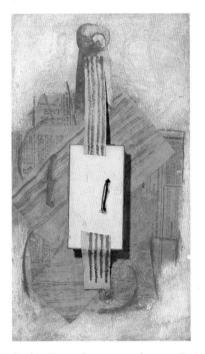

Violin, late December 1913–early 1914, Paris.
Cardboard box, pasted papers, gouache, charcoal, and
chalk on cardboard, 20⅜ x 11¾ x 1⅝ in. (51.5 x 30 x 4 cm).

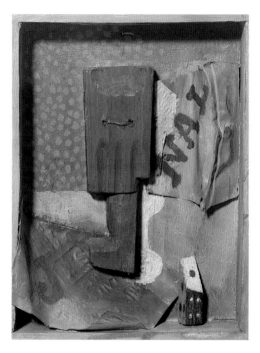

Glass, Newspaper, and Die, summer 1914, Avignon.
Painted wood and tin with wire on painted wooden support,
6⅞ x 5⅜ x 1¼ in. (17.4 x 13.5 x 3 cm).

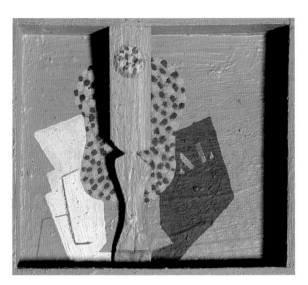

Glass and Newspaper, summer 1914, Avignon.
Painted wood and pencil on painted wooden support,
6 x 6⅞ x 1¼ in. (15.4 x 17.5 x 3 cm).

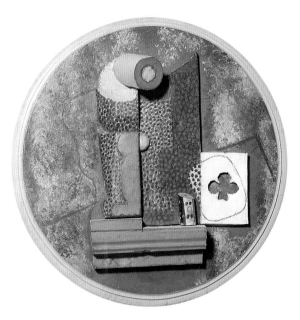

Glass, Pipe, Ace of Clubs, and Die, summer 1914, Avignon.
Painted wood and metal on painted wooden support,
diameter: 13⅜ in. (34 cm); depth: 3⅜ in. (8.5 cm).

Guitar, spring 1926, Paris.
Canvas, wood, rope, nails, and bolts on painted panel,
51¼ x 38 in. (130 x 96.5 cm).

Guitar, spring 1926, Paris.
String, newspaper, floor rag, and nails on painted canvas,
37¾ x 51¼ in. (96 x 130 cm).

Guitar, April 29, 1926, Paris.
Cardboard, tulle, string, and pencil on cardboard,
4⅞ x 4⅛ in. (12.5 x 10.4 cm).

Guitar, April 31 [*sic*], 1926, Paris.
Tulle, cardboard painted in ink, string, and braid
on cardboard, 5⅝ x 3⅝ in. (14.2 x 9.5 cm).

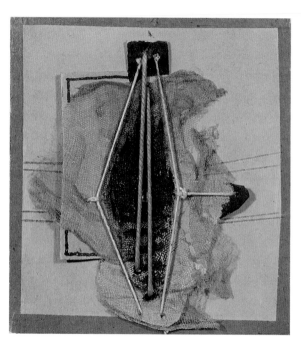

Guitar, May 1926, Paris.
Cardboard painted in ink, string, tulle, and pencil
on cardboard, 5⅜ x 5 in. (13.8 x 12.6 cm).

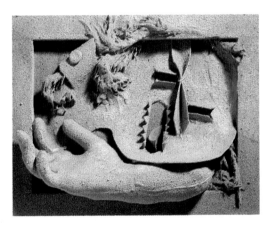

Composition with Glove, August 22, 1930, Juan-les-Pins.
Colored sand, glove, cardboard, and plant matter pasted and
sewn on canvas, 10¾ x 14 x 3⅛ in. (27.5 x 35.5 x 8 cm).

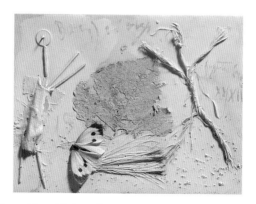

Composition with Butterfly, September 15, 1932, Boisgeloup.
Fabric, wood, plant matter, string, thumbtack, butterfly,
and oil on canvas, 6⅜ x 8⅝ x ⅝ in. (16 x 22 x 2.5 cm).

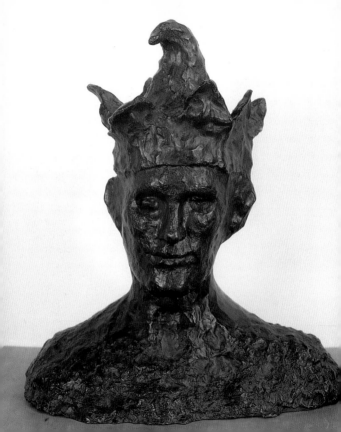

SCULPTURES

In 1905–6 making wood sculptures contributed to Picasso's invention of a monumental language uniquely his own. In 1907–8 he went back to the archaic technique of direct carving while leaning toward a reinterpretation of Primitivism.

In Cubism, his *Head of a Woman (Fernande)* (page 151) is symptomatic of a new treatment of volume by reducing it to planes. The puzzle remained the same for Picasso whether it was in two dimensions or three. The works of 1912–15 sum up all Cubist research, expressing the relationship between painting and sculpture. According to the artist, "It would have been sufficient to cut up [the pictures] according to the indications given by the color in order to be confronted with a sculpture." In Cubist sculpture, forms are not imitated but transposed, as in *Violin* of 1915 (page 160). The only real work in full relief dating to that period is the 1914 *Glass of Absinthe*.

In 1928–30 Picasso worked on welded-metal sculptures in Julio González's studio. He made models in 1928 for a monument to Guillaume Apollinaire (page 165), one of which was enlarged to monumental scale in 1985.

During 1930–35, while Picasso was living with Marie-Thérèse in Boisgeloup, he worked mainly on full-relief sculpture. It was during this period that he executed *Woman with Leaves* (page 177), which was so admired by André Malraux.

The Reaper, an allegory of oppressed Spain and death, was made in 1943. *Man with a Sheep* (page 183) was hastily cast that same year after being entirely modeled. Despite Picasso's denial, one can see in it a memory of the Good Shepherd and John the Baptist.

At Vallauris in 1950–51 Picasso assembled mundane found objects, embedding them in plaster. "Picasso, inspired ragpicker" (as Jean Cocteau called him) invented an inexhaustible art of surprises, also exemplified, though a bit less effectively, in bronze casts such as *The She Goat* (page 187). During 1954–62 Picasso worked on cut-out and painted sheet-metal pieces; he also enlarged works originally made in paper by casting them in concrete (as in *Woman with Outstretched Arms,* page 193), in order to realize his dream of working in monumental scale.

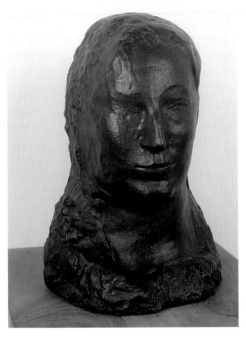

Head of a Woman (Fernande), 1906, Paris.
Bronze, 13¾ x 9⅜ x 9¾ in. (35 x 24 x 25 cm).

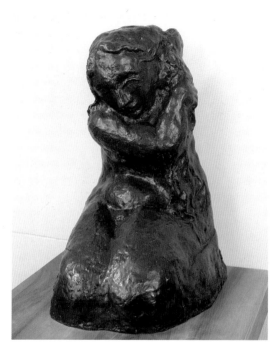

Woman Combing Her Hair, 1906, Paris.
Bronze, 16⅝ x 10¼ x 12½ in. (42.2 x 26 x 31.8 cm).

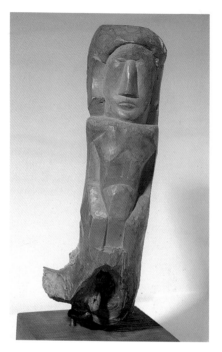

Figure, 1907, Paris.
Boxwood with traces of pencil, paint on top of head,
13⅞ x 4¾ x 4⅝ in. (35.2 x 12.2 x 12 cm).

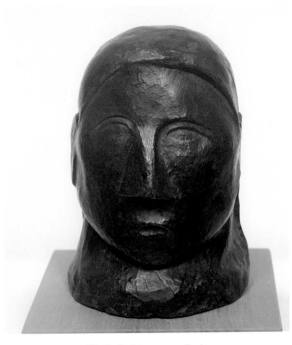

Head of a Man, 1907, Paris.
Partially painted beech,
14⅝ x 7¾ x 4⅝ in. (37 x 20 x 12 cm).

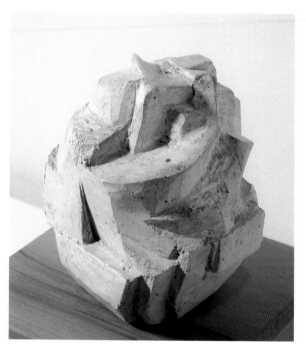

Apple, 1909, Paris.
Plaster, 4½ x 3⅞ x 3 in. (11.5 x 10 x 7.5 cm).

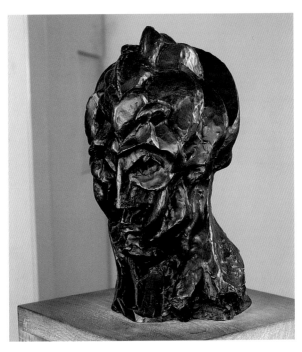

Head of a Woman (Fernande), fall 1909, Paris.
Bronze, 15⅞ x 9 x 10¼ in. (40.5 x 23 x 26 cm).

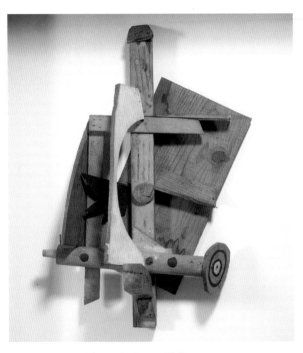

Mandolin and Clarinet, [fall] 1913, Paris.
Painted wood and pencil,
22¾ x 14¼ x 9¼ in. (58 x 36 x 23 cm).

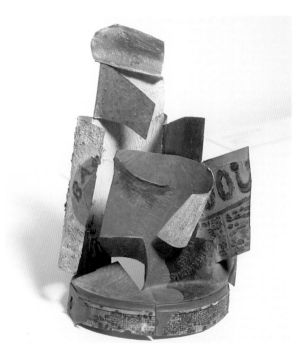

Bottle of Bass, Glass, and Newspaper, spring 1914, Paris.
Painted tin, sand, wire, and paper,
8⅛ x 5½ x 3⅜ in. (20.7 x 14 x 8.5 cm).

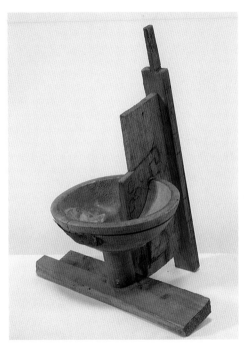

Bottle of Anis del Mono and Fruit Bowl with Grapes,
[fall] 1915, Paris. Pine, tin, nails, and charcoal,
13⅞ x 10¾ x 10¼ in. (35.5 x 27.5 x 26 cm).

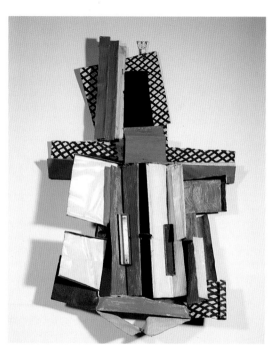

Violin, [1915], Paris.
Cut, folded, and painted sheet metal and wire,
39⅜ x 25⅛ x 7⅛ in. (100 x 63.7 x 18 cm).

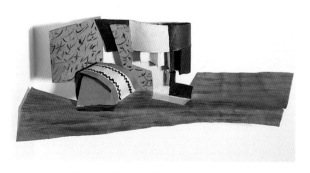

Glass and Pack of Tobacco, 1921, Paris.
Cut, folded, and painted sheet metal and wire,
5¾ x 19⅜ x 6⅜ in. (14.7 x 49.2 x 16.3 cm).

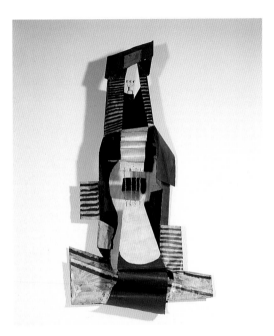

Guitar, 1924, Paris.
Cut, folded, and painted sheet metal, painted tin box,
and wire, 43⅝ x 25 x 10½ in. (111 x 63.5 x 26.6 cm).

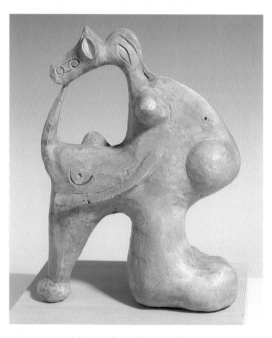

Metamorphosis II, 1928, Paris.
Original plaster,
9⅛ x 7⅛ x 4⅜ in. (23 x 18 x 11 cm).

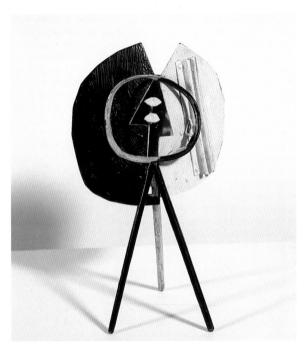

Head, October 1928, Paris.
Painted brass and iron,
7⅛ x 4⅜ x 2⅞ in. (18 x 11 x 7.5 cm).

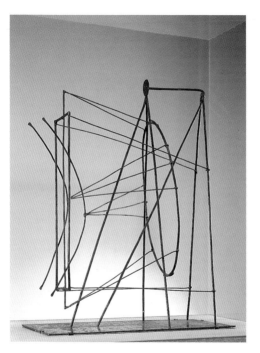

Figure (for a proposed monument to Guillaume Apollinaire),
fall 1928, Paris. Wire and sheet metal,
19⅞ x 7⅜ x 16⅛ in. (50.5 x 18.5 x 40.8 cm).

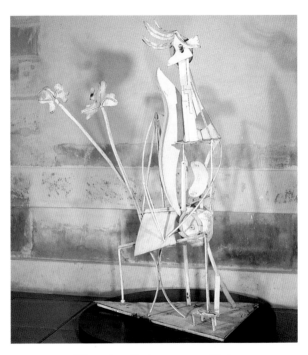

Woman in a Garden, 1929–30, Paris.
Welded and painted iron,
81⅛ x 46⅛ x 33½ in. (206 x 117 x 85 cm).

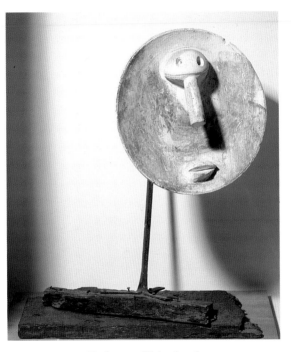

Head, 1931, [Boisgeloup].
Colored plaster, wood, iron, and nails,
22⅜ x 18⅞ x 9¼ in. (57 x 48 x 23.5 cm).

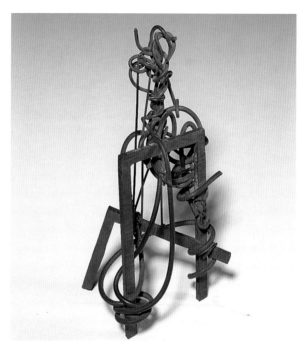

Figure, 1931, Paris or Boisgeloup.
Iron and wire, 10¼ x 4⅞ x 4⅜ in. (26 x 12.5 x 11.1 cm).

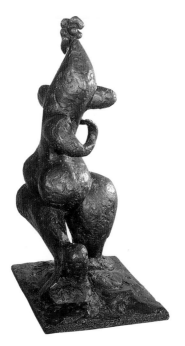

Bather, 1931, Boisgeloup.
Bronze (unique cast),
27½ x 15¾ x 12⅜ in. (70 x 40.2 x 31.5 cm).

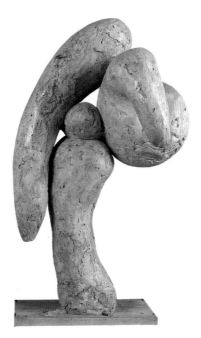

Head of a Woman, 1931, Boisgeloup.
Original plaster, 28⅛ x 16⅛ x 12⅞ in. (71.5 x 41 x 33 cm).

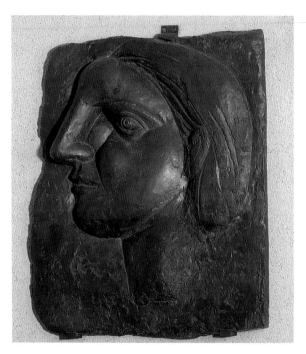

Head of a Woman in Profile (Marie-Thérèse), 1931, Boisgeloup.
Bronze (unique cast), 26⅞ x 23¼ x 3⅛ in. (68.5 x 59 x 8 cm).

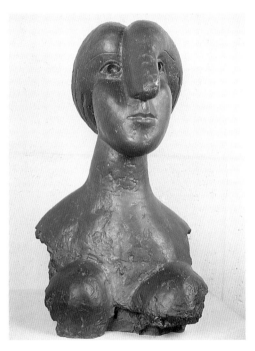

Bust of a Woman, 1931, Boisgeloup.
Bronze (unique cast), 30⅝ x 17½ x 21¼ in.
(78 x 44.5 x 54 cm).

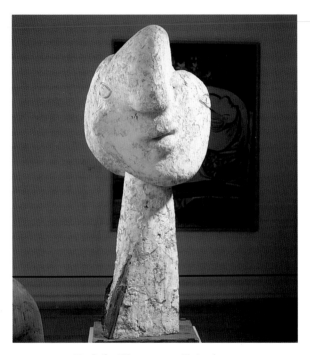

Head of a Woman, 1931, Boisgeloup.
Original plaster (plaster and wood),
50⅝ x 21½ x 24⅝ in. (128.5 x 54.5 x 62.5 cm).

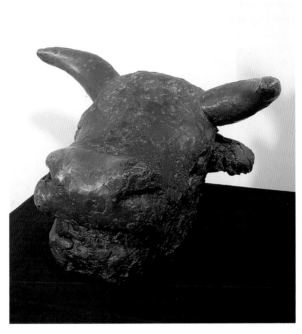

Head of a Bull, 1931–32, Boisgeloup.
Bronze (unique cast),
13⅝ x 21⅝ x 20⅞ in. (35 x 55 x 53 cm).

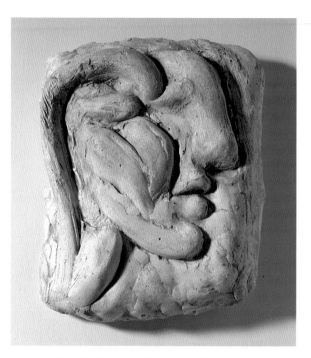

Head of a Woman in Profile, 1933, Boisgeloup.
Plaster, 7½ x 6⅜ x 1¾ in. (19 x 16 x 4.5 cm).

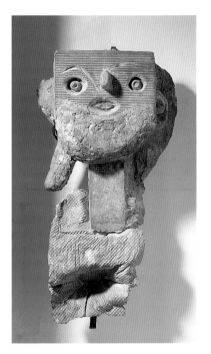

Bust of a Bearded Man, 1933, Boisgeloup.
Original plaster, 33⅜ x 18½ x 12¼ in. (85.5 x 47 x 31 cm).

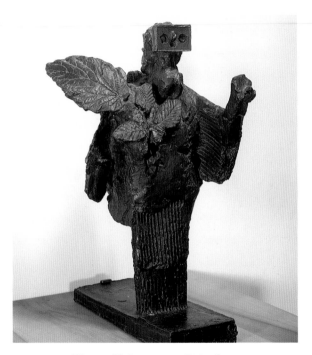

Woman with Leaves, 1934, Boisgeloup.
Bronze (unique cast),
14⅞ x 7⅞ x 10¼ in. (37.9 x 20 x 25.9 cm).

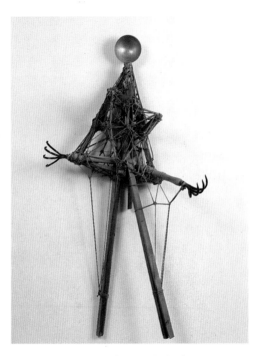

Figure, 1935, Paris or Boisgeloup.
Ladle, claws, wood, string, and nails,
44⅛ x 24¼ x 11⅝ in. (112 x 61.5 x 29.8 cm).

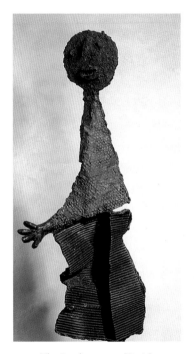

The Speaker, 1937, [Paris].
Bronze and stone (unique cast),
72¼ x 25⅞ x 10⅝ in. (183.5 x 66 x 27 cm).

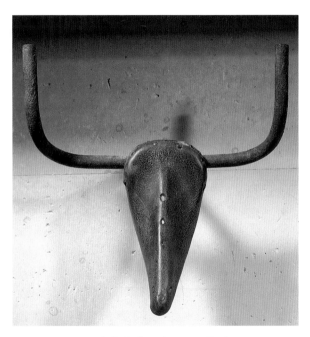

Head of a Bull, spring 1942, Paris.
Bronze (original components: leather seat and metal handlebar), 13¼ x 17⅛ x 7½ in. (33.5 x 43.5 x 19 cm).

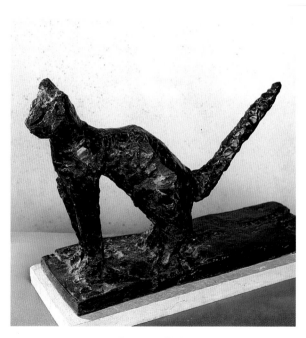

Cat, 1943, Paris.
Bronze, 14¼ x 6⅞ x 21⅝ in. (36 x 17.5 x 55 cm).

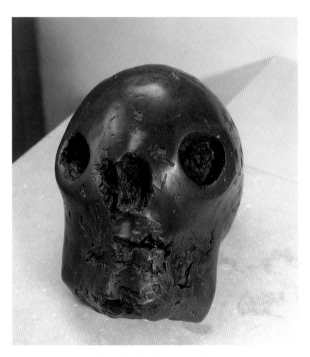

Death's Head, 1943, Paris.
Bronze and brass,
9¾ x 8⅜ x 12¼ in. (25 x 21 x 31 cm).

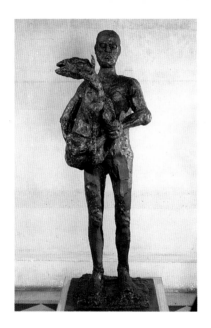

Man with a Sheep, February or March 1943, Paris.
Bronze, 87⅝ x 30⅝ x 30⅝ in. (222.5 x 78 x 78 cm).

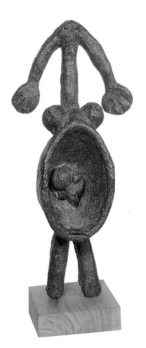

Small Pregnant Woman, 1948, Vallauris.
Bronze, 13⅜ x 3⅝ x 2⅞ in. (32.5 x 9 x 7 cm).

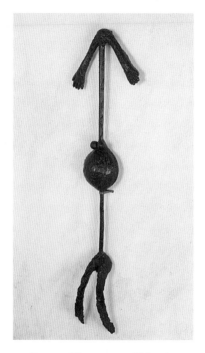

Pregnant Woman, 1949, Vallauris.
Bronze, 51¼ x 14⅝ x 4⅝ in. (130 x 37 x 11.5 cm).

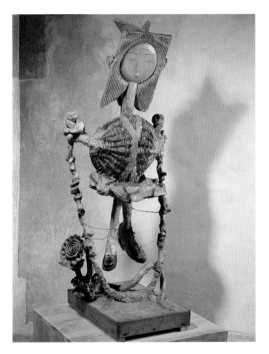

Girl Jumping Rope, 1950, Vallauris.
Original plaster, with wicker basket, cake mold, shoes, wood,
iron, and ceramic, 59¾ x 25⅝ x 26 in. (152 x 65 x 66 cm).

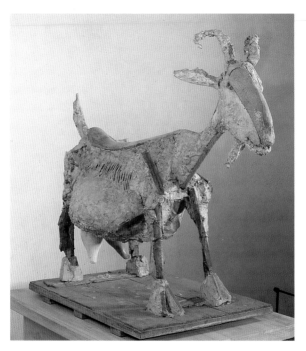

The She Goat, 1950, Vallauris. Original plaster, with wicker basket, ceramic pots, palm leaf, metal, wood, and cardboard, 47⅝ x 28⅜ x 56⅝ in. (120.5 x 72 x 144 cm).

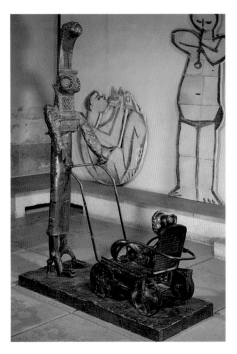

Woman with a Baby Carriage, 1950, Vallauris.
Bronze, 79⅞ x 57⅛ x 24 in. (203 x 145 x 61 cm).

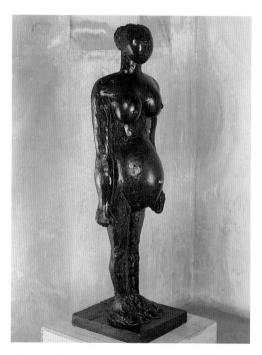

Pregnant Woman (second state), 1950–59, Vallauris.
Bronze, 42⅞ x 11¾ x 13⅜ in. (109 x 30 x 34 cm).

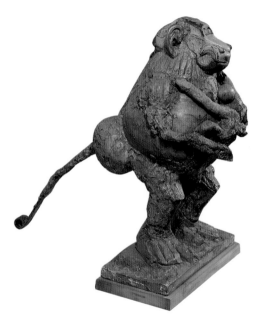

Baboon and Young, October 1951, Vallauris.
Original plaster, with ceramic, two toy cars, and metal,
22⅛ x 13⅜ x 28 in. (56 x 34 x 71 cm).

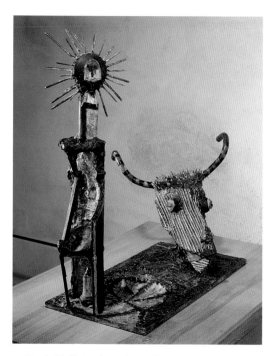

Goat's Skull, Bottle, and Candle, 1951–53, Vallauris.
Painted bronze, 31 x 36⅝ x 21⅜ in. (79 x 93 x 54 cm).

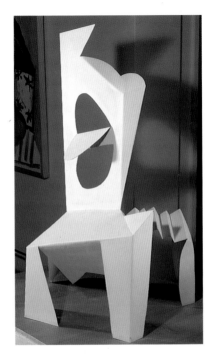

The Chair, 1961, Cannes.
Cut, folded, and painted sheet metal,
43⅞ x 45⅛ x 35 in. (111.5 x 114.5 x 89 cm).

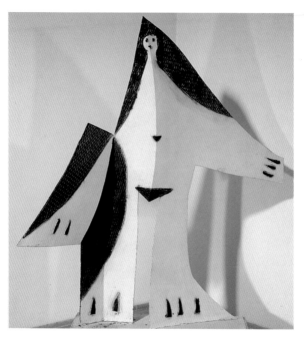

Woman with Outstretched Arms (for a monument at Saint-Hilaire), 1961, Cannes. Cut, folded, and painted sheet metal with painted wire grating, 72⅛ x 69⅞ x 28½ in. (183 x 177.5 x 72.5 cm).

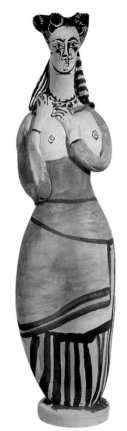

CERAMICS

Picasso always dreamed of renewing the Renaissance tradition of the "complete" artist. In 1946 he met Suzanne and Georges Ramié, who ran the pottery works in Vallauris called the Madoura Studio. Picasso settled in Vallauris in 1948, then in Cannes in early 1955. Inspired by the Mediterranean environment, he began to learn this new technique. Once again, his training was empirical, and he enriched this art with technical heresies, particularly in firing, and even with his failures. "An apprentice who worked like Picasso would never find a job," the Ramiés often commented.

True to himself, Picasso abolished limits, working both as a ceramist and a sculptor when he modeled his own pieces, as a painter and a sculptor through his experiments with glazes. Sometimes he used traditional wares as his support; sometimes he worked with mass-produced objects or discards; and sometimes he sculpted his figures out of raw clay, creating a whole little population of Mediterranean gods and goddesses. Picasso's paganism and profane grandeur, characteristic of an artist for whom art was everything but a religion, expressed themselves more clearly in ceramic than anywhere else.

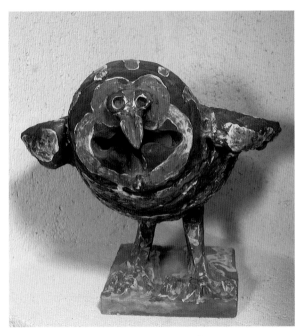

Angry Owl, 1950[–53], Vallauris.
Cast white clay, decorated with red slip under glaze;
black-slip patina applied after firing,
11¼ x 11¾ x 12⅝ in. (28.5 x 30 x 32 cm).

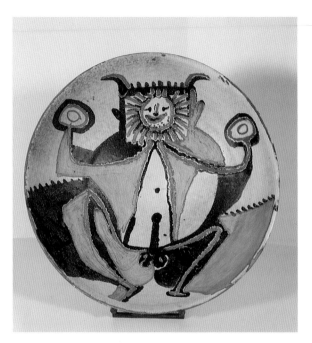

Cup with Faun and Cymbals (two figures on back), May 10, 1957, Vallauris. Thrown white clay, covered with iron oxide and white mat enamel, decorated with metallic oxide, incised and scraped, diameter: 11⅜ in. (29 cm); depth: 3¼ in. (8 cm).

A la escuela.

DRAWINGS AND WATERCOLORS

"If I had to choose from his whole creation," Henri Michaux said of Picasso, "I would take his drawings without hesitating."

About his childhood drawings, Picasso declared: "I never did any. At that age, I was drawing like Raphael." During the period from 1893 to 1906 he completed his academic training, then came in contact with modernist tendencies in Barcelona and was influenced by Henri de Toulouse-Lautrec (see, for example, Picasso's *Study for a Carnival Poster,* page 204). He developed the theme of acrobats, which he continued in Paris during his Blue and Rose periods.

The museum owns eight sketchbooks (1906–9) for *Les Demoiselles d'Avignon,* allowing us to follow the creative progression of that work, beginning with Picasso's first thoughts under the influence of Jean-Auguste-Dominique Ingres and Paul Cézanne. One hundred fifty-five drawings from 1909–17 show the interpenetration of all disciplines within Cubism, illustrating the style's evolution from the "Cézannesque" Cubism of 1908–9 to the late anthropomorphic guitars.

In 1917–24 Picasso executed the large pastels of his

"classicist" period and the theatrical scenery that resulted from a collective enterprise very unlike the complete solitude of his Cubist years. The still life with musical instruments is a theme borrowed from the curtain he designed for *The Three-Cornered Hat*. The scenes of circus life executed during this period represent, according to Gertrude Stein, the "Rose Period" of his maturity.

Throughout his life Picasso had a deep interest in illustrating literature, whether by Ovid or his friend the poet Max Jacob. In 1926 he made his first drawings for Honoré de Balzac's *Unknown Masterpiece*. Nine years later he painted *Minotauromachy,* with its cruel scenes based on his own personal mythology.

Erotic subjects prevailed in Picasso's final years, embodied in the theme of the painter and his model. In the same vein was his series on La Californie, the artist's studio and dwelling place in 1955. With a distant irony but the persistence that kept bringing him back to his fundamental theme, Picasso was fully a man because he was fully an artist.

The Artist's Mother and Sister Embroidering, 1896, Barcelona.
Brown ink wash and gouache on paper,
6½ x 8⅝ in. (16.5 x 22.2 cm).

Bullfight, [1897–98].
Pen and brown ink, colored pencil on paper,
5¼ x 8⅜ in. (13.2 x 21 cm).

Silhouette of José Ruiz (the Artist's Father) with Raincoat,
1899, Barcelona. Pencil on paper,
12⅝ x 8⅝ in. (32 x 22 cm).

Study for a Carnival Poster, late 1899, Barcelona.
Oil and pencil on paper, 19 x 12⅝ in. (48.2 x 32 cm).

Allegory: Young Man, Woman, and Grotesques,
1899–1900, [Barcelona].
Charcoal and oil on paper,
13⅜ x 12⅜ in. (34.1 x 31.2 cm).

Reading the Letter, 1899–1900, Barcelona.
Charcoal, pencil, and oil on paper,
18⅞ x 25⅛ in. (48 x 63.7 cm).

Sheet of Studies: Head of Christ, Seated Old Woman, Woman in Profile, and Hand Holding a Brush, early 1901, Madrid. India ink and pastel on paper, 9¼ x 6⅛ in. (23.3 x 15.4 cm).

Study for "Evocation," spring–summer 1901, Paris.
Black pencil on back of reproduction of *Regreso de la fiesta di Napoli* . . . 1885, 16⅜ x 11⅜ in. (41.6 x 29 cm).

Study for "The Interview," winter 1901–2, [Paris–Barcelona].
Graphite on paper, 17⅝ x 12⅝ in. (45 x 32 cm).

Portrait of a Man, early 1902, Paris.
Charcoal on paper, 12⅝ x 9⅝ in. (32 x 24.4 cm).

Nude Woman Imploring the Heavens, December 1902, Paris.
Pen and brown ink, wash on paper,
12¼ x 9⅛ in. (31 x 23.2 cm).

Head of a Woman Screaming, January 1903, Paris.
Pen and brown and black ink on paper,
9⅛ x 7⅛ in. (23 x 18.1 cm).

Study for "The Embrace," early 1903, Barcelona.
Graphite on paper,
13½ x 6¾ in. (34.2 x 17.3 cm).

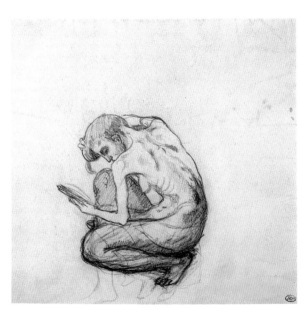

Woman with a Mirror, 1903, Barcelona.
Graphite on paper, 8⅝ x 9⅛ in. (21.8 x 23.1 cm).

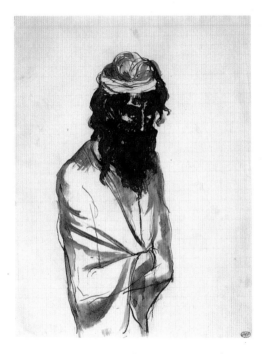

Bearded Man with Crossed Arms, 1903, Barcelona.
Black ink on squared paper, 11⅜ x 10⅝ in. (29 x 27 cm).

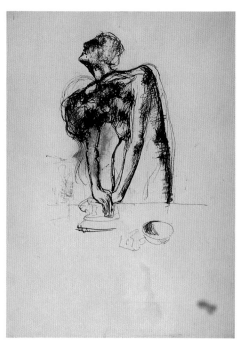

Study for "The Ironing Woman," spring 1904, Paris.
Pen and brown ink on paper, 14⅝ x 10⅝ in. (37 x 26.9 cm).

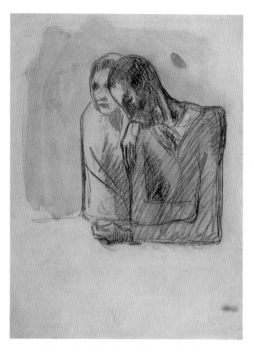

Study for "The Couple," 1904, Paris.
Pencil on wash on paper, 14⅝ x 10⅝ in. (37 x 27 cm).

Family of Acrobats, 1905, Paris.
Graphite, pencil, and brown pencil highlights on paper,
14⅝ x 10½ in. (37.2 x 26.7 cm).

Acrobats: Women Combing Their Hair, 1905, Paris.
Pen and black ink on paper, 10 x 7 in. (25.5 x 17.6 cm).

Study for "The Death of Harlequin," 1905–6, Paris.
Pen and black ink on blue-gray paper,
6⅝ x 9⅜ in. (16.7 x 23.7 cm)

Studies for Self-Portraits, fall 1906, Paris.
Graphite on paper, 12⅞ x 18⅝ in. (31.5 x 47.5 cm).

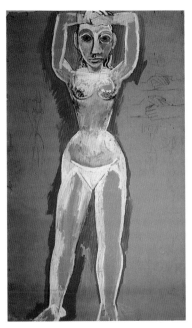

Frontal Nude with Raised Arms
(studies for *Les Demoiselles d'Avignon*), spring 1907, Paris.
Gouache, charcoal, and graphite on canvas-backed paper
on canvas, 51⅝ x 29⅝ in. (131 x 75.5 cm).

Standing Nude (proportion studies for
Les Demoiselles d'Avignon), spring 1907, Paris.
Pen and india ink on stencil paper,
12¼ x 5 in. (31 x 12.6 cm).

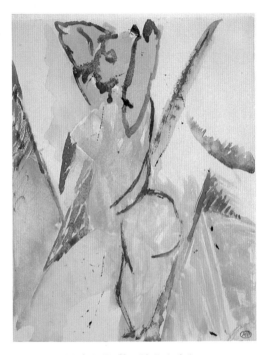

Nude in Profile with Raised Arms
(study for *Les Demoiselles d'Avignon*), May–June 1907, Paris.
Watercolor on paper, 8¾ x 6⅞ in. (22.3 x 17.5 cm).

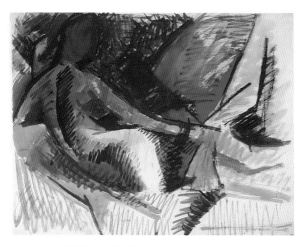

Odalisque, after Ingres, summer 1907, Paris.
Blue ink and gouache over graphite on paper,
18¾ x 24⅝ in. (47.7 x 62.5 cm).

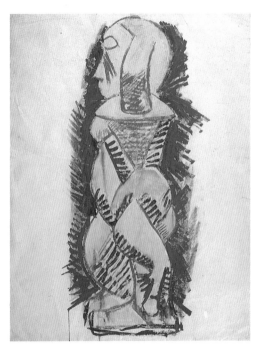

Standing Nude in Profile, spring 1908, Paris.
Gouache and pastel on paper, 24⅝ x 18⅞ in. (62.5 x 48 cm).

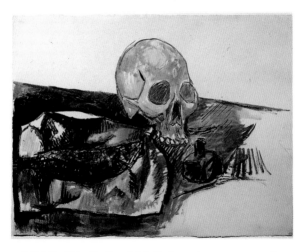

Still Life: Fish, Skull, and Ink Bottle, spring–summer 1908,
Paris. India ink and wash on paper,
18¾ x 24¾ in. (47.7 x 63 cm).

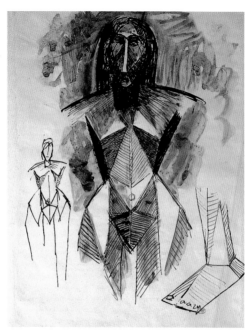

Standing Nudes and Study for a Foot,
summer 1908, [La Rue-des-Bois].
Pen, india ink, and watercolor on the back of an article,
"La Torre del lavoro di Rodin," 11¾ x 8⅞ in. (30 x 22.6 cm).

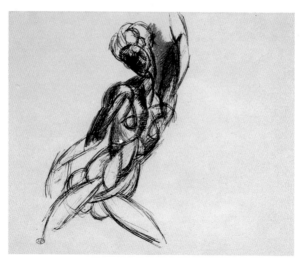

Nude Woman with Raised Arm, early 1909, Paris.
Pen and india ink, wash on paper,
9⅜ x 12½ in. (23.6 x 31.7 cm).

Houses and Palm Trees, April–May 1909, Barcelona.
Pen and black ink on paper, 6¾ x 5⅜ in. (17.3 x 13.5 cm).

Study for Head of a Woman (Fernande),
summer 1909, Horta de Ebro, Spain.
Pencil on paper, 24⅝ x 18⅞ in. (62.8 x 48 cm).

Violin Player, summer 1912, Sorgues.
Pen and brown ink, india ink, and oil on paper,
12⅛ x 7⅝ in. (30.7 x 19.5 cm).

Guitar Player with a Hat, [spring–summer] 1913, Céret.
India ink and wash on sheet from tax ledger from the
Revolutionary period with inscriptions in brown ink,
14⅛ x 9⅛ in. (35.7 x 23.1 cm).

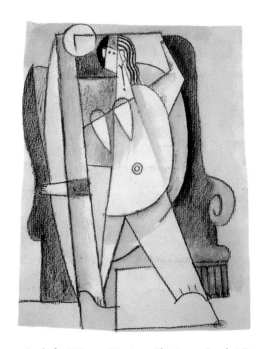

Study for "Woman Wearing a Shirt in an Armchair,"
fall 1913, Paris.
Wash, pencil, and brown pencil highlights on paper,
7⅜ x 5¾ in. (18.5 x 14.6 cm).

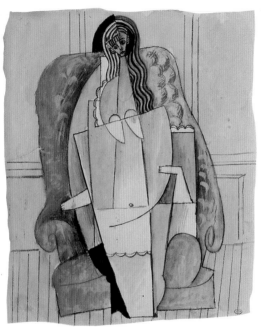

Study for "Woman Wearing a Shirt in an Armchair,"
fall 1913, Paris.
Gouache and pencil on paper,
12⅞ x 10⅝ in. (32.7 x 27 cm).

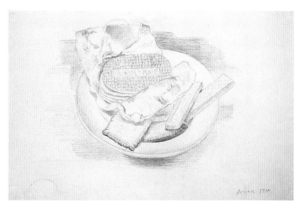

Still Life with Biscuits, summer 1914, Avignon.
Graphite on paper, 12⅛ x 19 in. (30.8 x 48.2 cm).

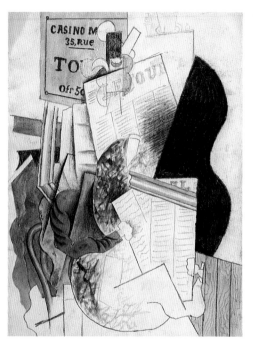

Man Reading a Newspaper, summer 1914, Avignon.
Watercolor and graphite on paper,
12⅝ x 9⅜ in. (32.1 x 23.9 cm).

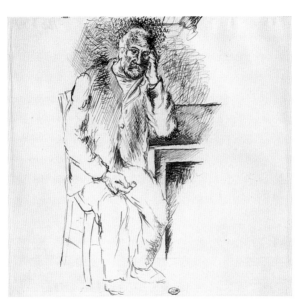

Bearded Man with a Pipe, at a Table, summer 1914, Avignon.
Pen and brown ink on paper, 8¼ x 8⅝ in. (20.9 x 21.8 cm).

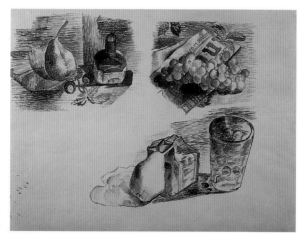

Three Still Lifes, fall 1914, Avignon.
Pen and brown ink on paper, 15 x 19½ in. (38 x 49.5 cm).

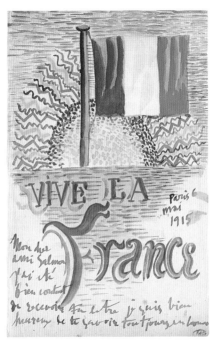

"Long Live France" (letter to André Salmon), May 6, 1915, Paris.
Gouache, watercolor, and india ink on paper,
6⅞ x 4⅜ in. (17.5 x 11.1 cm).

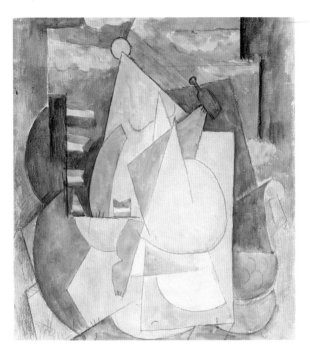

Nude Woman Sitting in an Armchair, late 1915–early 1916, Paris.
Watercolor and graphite on paper,
8¾ x 7¾ in. (22.3 x 19.9 cm).

241

Study for "Parade" Curtain, 1916–17, Paris–Rome.
Watercolor and graphite on paper,
10¾ x 15⅝ in. (27.3 x 39.5 cm).

Study for an Acrobat's Costume in "Parade,"
1916–17, Paris–Rome.
Watercolor and graphite on paper,
11 x 8⅛ in. (28 x 20.5 cm).

Portrait of Apollinaire with Bandaged Head, 1916, Paris.
Black chalk on paper, 10⅛ x 8⅞ in. (25.7 x 22.5 cm).

Portrait of Apollinaire, summer 1918, Biarritz.
Pen and purple ink on paper, 5⅜ x 3⅜ in. (13.5 x 8.7 cm).

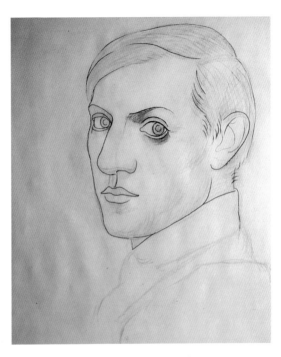

Self-Portrait, [1917–19].
Graphite and charcoal on paper,
25¼ x 19½ in. (64 x 49.5 cm).

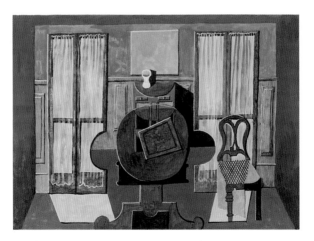

The Artist's Dining Room, on rue La Boétie, 1918–19, Paris.
Gouache and india ink on paper,
8⅝ x 12⅜ in. (22.1 x 31.6 cm).

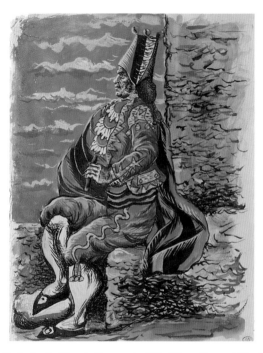

Study for the Torero's Costume in "The Three-Cornered Hat,"
1919, London. Gouache on paper, 10¼ x 7⅞ in. (26 x 20 cm).

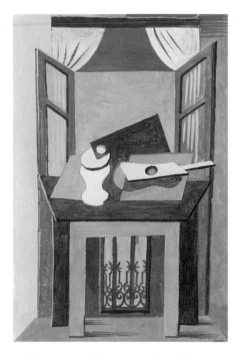

Still Life on a Table before an Open Window,
October 26, 1919, [Paris].
Gouache on paper, 6⅜ x 4⅛ in. (15.9 x 10.5 cm).

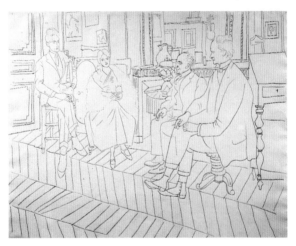

The Artist's Living Room on rue La Boétie: Jean Cocteau, Olga, Erik Satie, and Clive Bell, November 21, 1919, Paris. Graphite on paper, 19⅜ x 24 in. (49 x 61 cm).

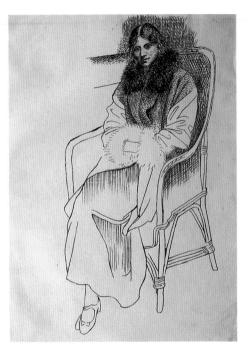

Olga in an Armchair, [late 1919], Paris.
Pen and black ink on paper,
10½ x 7¾ in. (26.7 x 19.7 cm).

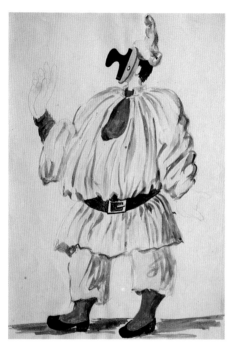

Study for Pulcinella's Costume in "Pulcinella," 1920, Paris.
Gouache and graphite on paper, 13⅜ x 9⅜ in. (34 x 23.5 cm).

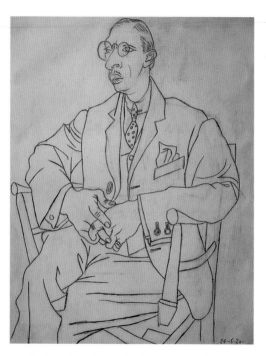

Portrait of Igor Stravinsky, May 24, 1920, Paris.
Graphite and charcoal on paper,
24¼ x 10 in. (61.5 x 48.2 cm).

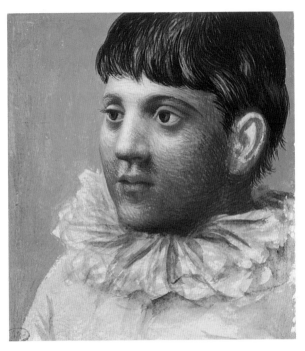

Portrait of a Teenager as Pierrot, December 27, 1922, Paris.
Gouache and watercolor on paper,
4⅝ x 4⅛ in. (11.8 x 10.5 cm).

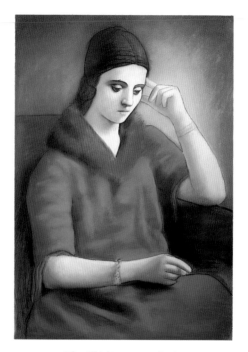

Olga Thinking, 1923, Paris.
Pastel and pencil on paper, 40⅞ x 28 in. (104 x 71 cm).

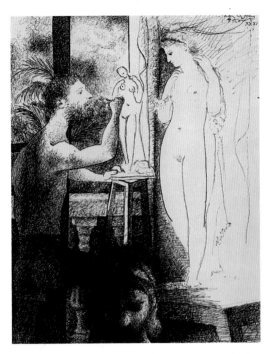

The Sculptor and His Model, August 4, 1931, Juan-les-Pins.
Pen and india ink on paper, 12¾ x 10 in. (32.4 x 25.5 cm).

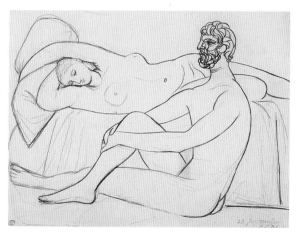

Sleeping Woman and Seated Man,
September 22, 1931, [Boisgeloup–Paris].
Graphite on paper, 10¼ x 13¾ in. (26 x 35 cm).

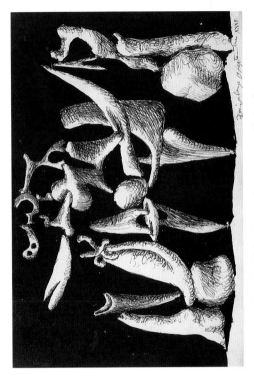

The Crucifixion, September 19, 1932, Boisgeloup.
India ink on paper, 13⅜ x 20 in. (34 x 51 cm).

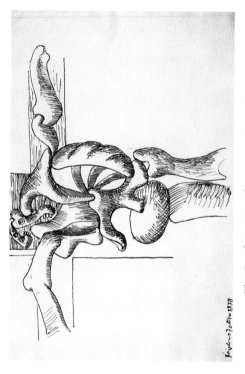

The Crucifixion, October 7, 1932, Boisgeloup.
Pen and india ink on paper, 13⅜ x 20 in. (34 x 51 cm).

Anatomy: Three Women, March 1, 1933, [Paris].
Graphite on paper, 7¾ x 10⅝ in. (19.7 x 27.1 cm).

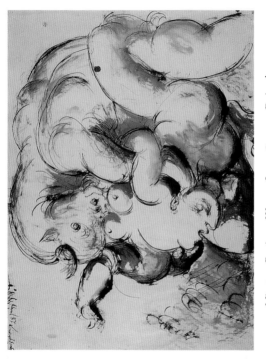

Minotaur Raping a Woman, June 28, 1933, Boisgeloup.
Pen and india ink, wash on paper, 18½ x 24⅜ in. (47 x 62 cm).

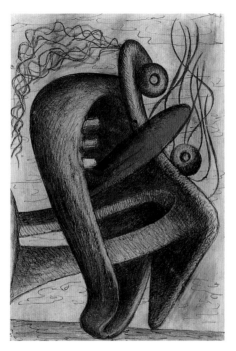

Figure by the Sea, November 19, 1933, Paris.
Pastel, india ink, and charcoal on paper,
20⅛ x 13½ in. (51 x 34.2 cm).

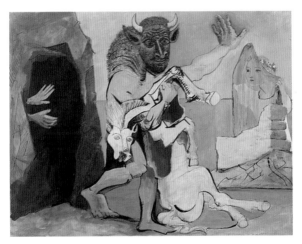

Minotaur and Dead Mare in Front of a Grotto Facing a Young Girl with Veil, May 6, 1936, Juan-les-Pins. Gouache and india ink on paper, 19⅝ x 25⅝ in. (50 x 65 cm).

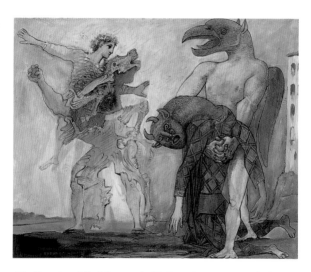

The Remains of the Minotaur in Harlequin's Costume (study for the curtain of *July 14,* by Romain Rolland), May 28, 1936, Paris. Gouache and india ink on paper, 17½ x 21½ in. (44.5 x 54.5 cm).

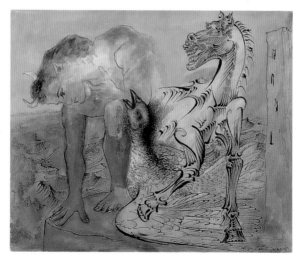

Faun, Horse, and Bird, August 5, 1936, [Paris].
Gouache and india ink on paper,
17⅜ x 21⅜ in. (44 x 54 cm).

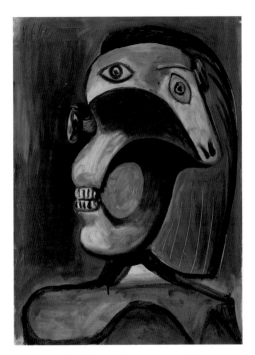

Head of a Woman, June 11, 1940, Royan.
Oil on paper, 25½ x 17⅝ in. (64.8 x 45 cm).

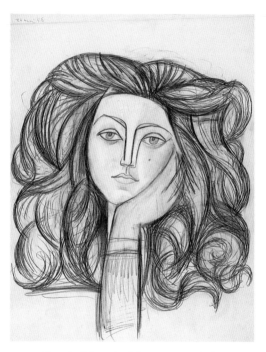

Portrait of Françoise, May 20, 1946, Paris.
Graphite, charcoal, and colored pencil on paper,
26 x 19⅞ in. (66 x 50.6 cm).

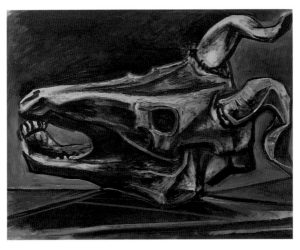

Ram's Skull, April 1, 1952.
Oil on paper, 20⅛ x 26 in. (51 x 66 cm).

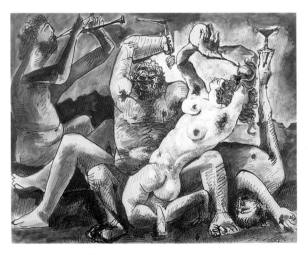

Bacchanalia, September 22–23, 1955, Cannes.
Pen and india ink, wash with white gouache highlights
on paper, 19⅝ x 25¾ in. (50 x 65.5 cm).

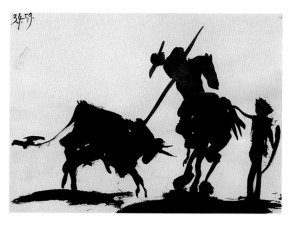

Notebook 21 of the Jacqueline Picasso "Dation," April 3, 1959,
Vallauris. India ink, wash, and litho pencil on paper,
10⅝ x 15 in. (27 x 38 cm).

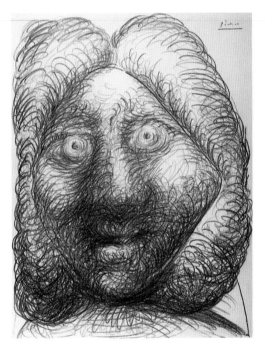

Head of a Man, July 4, 1972, Mougins.
Pencil on paper, 25⅞ x 19¾ in. (65.8 x 50.3 cm).

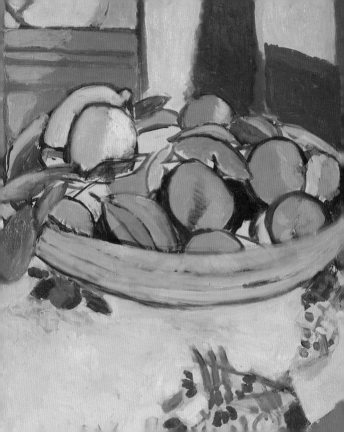

PICASSO'S PERSONAL COLLECTION

There is an imaginary museum within the Musée Picasso: the personal collection accumulated by the artist for the purpose of establishing a dialogue with the masters of the past. Picasso, like some of his contemporaries, took inspiration throughout his life from his predecessors' formal repertories. Thus, the works displayed in this section have a double value: their own intrinsic quality and the illumination of their owner. Picasso knew better than anyone else how to invent forebears for himself while remaining faithful to his friendships.

Part of Picasso's personal collection was included in the donation of 1973. It comprises some sources of Cubism: notably, Paul Cézanne and Henri Rousseau; and some contemporaries of Picasso, among which Henri Matisse is especially well represented by his masterpiece *Still Life with Oranges* (opposite and page 301). There are some old masters, such as the Le Nain brothers, Jean-Baptiste-Siméon Chardin, Gustave Courbet, and Camille Corot, all of whose work Picasso paraphrased, as he did the monotypes of Edgar Degas. The 1979 *dation* includes numerous homages and gifts, such as a gouache cutout by Matisse dedicated to Picasso; and works from his

Surrealist friends, such as a portfolio by Giorgio de Chirico that was formerly owned by Paul Eluard.

A large part of Picasso's personal collection focuses on primitive art, with works whose quality was less important than the "understanding of their spirit," according to D. H. Kahnweiler. Their presence allows us to study their impact on Picasso's work, particularly in the development of Cubism. The Nevinbumbaau head-dress of New Hebrides (opposite) was a gift from Matisse to Picasso; the *Mukuyi Mask* (page 277) is represented on the left side of Picasso's *Portrait of Kahnweiler.*

Picasso also had a passion for Iberian statuettes (the first *dation* includes ex-votos in bronze representing suppliants from the 8th to the 5th century B.C.). These works, which may have been acquired very early by Picasso, played an instrumental role during the first stage of painting *Les Demoiselles d'Avignon,* at the end of 1906.

Picasso's eclectic enthusiasm is most interesting in the way he made use of it in his own process of creating. Convinced that "in art there is no past and no future," he combined various sources, always searching for unknown wonders in the midst of the familiar. "Knowing how to perceive that was his genius," commented Michel Leiris.

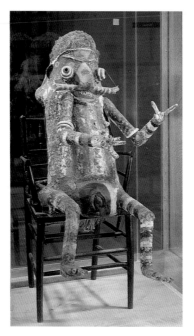

Ceremonial "Nevinbumbaau" Headdress, n.d.
Vanuatu (South Malekula, New Hebrides).
Ferns and screw pine covered with painted clay,
44⅞ x 23⅝ x 36¼ in. (114 x 60 x 92 cm).

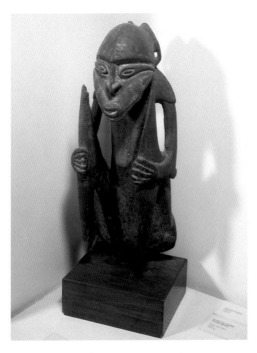

Sculpture (Fragment), n.d.
New Guinea, Bas Sepik.
Wood, 17⅞ x 7⅞ x 6⅞ in. (45.5 x 20 x 17.5 cm).

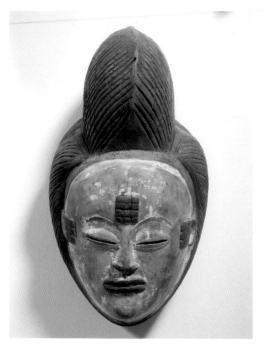

Mukuyi Mask, n.d. Punu (Gabon, left bank of the Ngunie).
Kapok-tree wood and kaolin powder,
11 x 6⅜ x 5⅛ in. (28 x 16 x 13 cm).

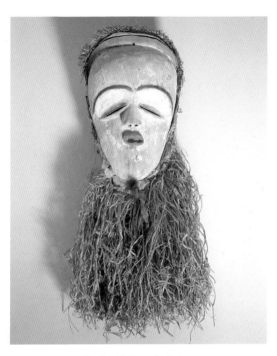

Tsogho Mask, n.d. Gabon.
Wood covered with white clay, raffia,
11 x 7⅛ x 4⅝ in. (28 x 18 x 12 cm).

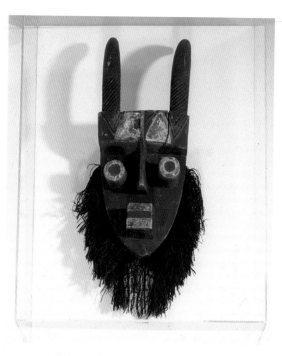

Grebo Mask, n.d. Grebo (Ivory Coast).
Wood, white paint, and plant fibers,
25¼ x 10 x 6¾ in. (64 x 25.5 x 16 cm).

Iberian Praying Figure, 6th–5th centuries B.C.
Bronze, 3⅜ x 1½ x ⅝ in. (8.4 x 3.7 x 1.7 cm).

Iberian Bull, n.d.
Bronze, 2 x 1⅛ x 2¾ in. (5.1 x 2.7 x 7.3 cm).

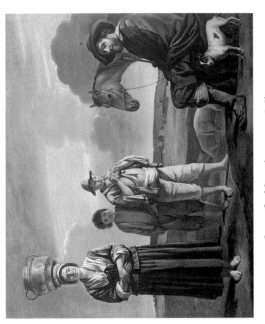

Louis Le Nain (c. 1593–1648).
The Rider's Halt, n.d.
Oil on canvas, 22³⁄₈ x 26³⁄₈ in. (57 x 67 cm).

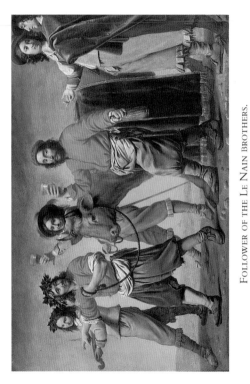

FOLLOWER OF THE LE NAIN BROTHERS.
The Procession of the Fatted Cow, or *The Wine Festival,* n.d.
Oil on canvas, 42½ x 63⅜ in. (108 x 166 cm).

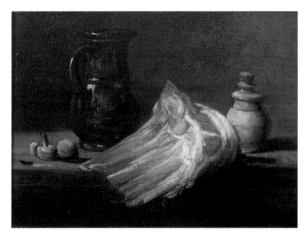

JEAN-BAPTISTE-SIMÉON CHARDIN (1699–1779).
Kitchen Table and Utensils with Cut of Mutton, c. 1770.
Oil on canvas, 13⅜ x 18⅛ in. (34 x 46 cm).

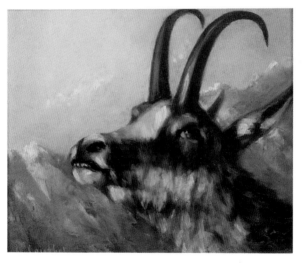

GUSTAVE COURBET (1819–1877).
Head of a Chamois Goat, n.d.
Oil on canvas, 15 x 18⅛ in. (38 x 46 cm).

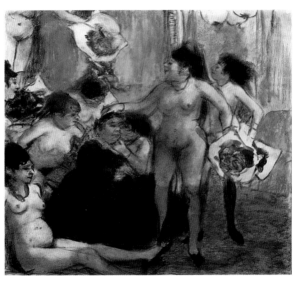

EDGAR DEGAS (1834–1917).
The Madame's Party, 1878–79.
Monotype in black ink highlighted with pastel on paper,
10½ x 11⅝ in. (26.6 x 29.6 cm).

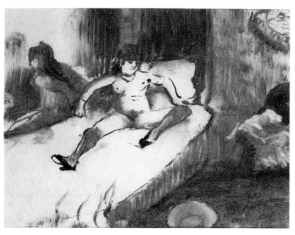

EDGAR DEGAS (1834–1917).
The Rest on the Bed, 1879.
Monotype in black ink on China paper,
4¾ x 6½ in. (12.1 x 16.4 cm).

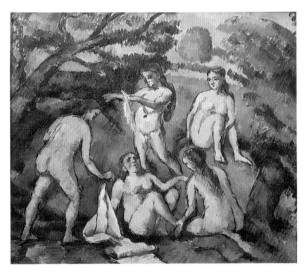

PAUL CÉZANNE (1839–1906).
Five Bathers, 1877–78.
Oil on canvas, 18 x 21⅜ in. (45.8 x 55.7 cm).

PAUL CÉZANNE (1839–1906).
The Sea at L'Estaque, 1878–79.
Oil on canvas, 28⅝ x 36¼ in. (73 x 92 cm).

PAUL CÉZANNE (1839–1906).
View of the Château Noir, 1905.
Oil on canvas, 29⅛ x 37 in. (74 x 94 cm).

PAUL CÉZANNE (1839–1906). *Landscape: Aix Cathedral*, 1904–6.
Watercolor over graphite on paper,
12⅝ x 18⅞ in. (32 x 48 cm).

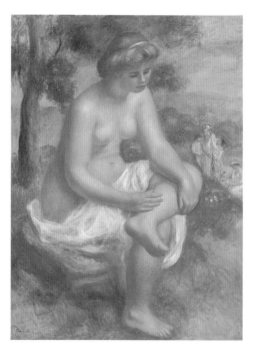

PIERRE-AUGUSTE RENOIR (1841–1919).
Bather Seated in a Landscape, or *Eurydice,* [1895–1900].
Oil on canvas, 45⅝ x 35 in. (116 x 89 cm).

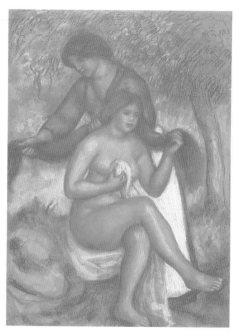

Pierre-Auguste Renoir (1841–1919).
The Hairdo, or *Woman Bathing*, [1900–1901].
Red and white chalk on canvas,
57⅛ x 40⅝ in. (145 x 103 cm).

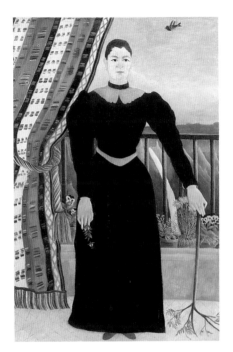

HENRI ROUSSEAU (1844–1910).
Portrait of a Woman, [1895].
Oil on canvas, 63 x 41⅜ in. (160 x 105 cm).

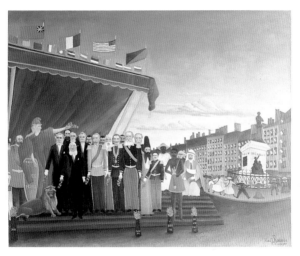

HENRI ROUSSEAU (1844–1910).
*The Representatives of Foreign Powers Salute
the Republic as a Token of Peace*, 1907.
Oil on canvas, 51¼ x 63⅜ in. (130 x 161 cm).

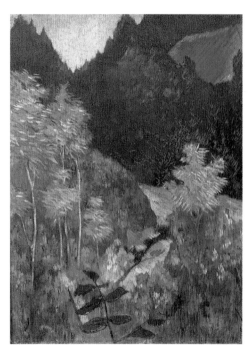

PAUL GAUGUIN (1848–1903).
Landscape, n.d.
Oil on canvas, 25⅝ x 19⅝ in. (65 x 50 cm).

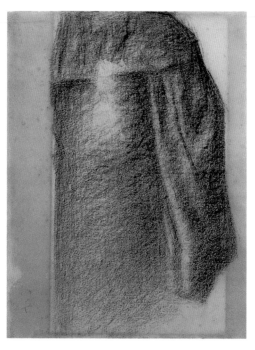

GEORGES SEURAT (1859–1891).
Study of a Skirt for "A Sunday on La Grande Jatte," 1884–85.
Conté pencil on paper, 11¾ x 6⅝ in. (30 x 17 cm).

EDOUARD VUILLARD (1868–1940). *The Lullaby,* [1896].
Oil on cardboard on wood panel,
11 x 19⅜ in. (28 x 49 cm).

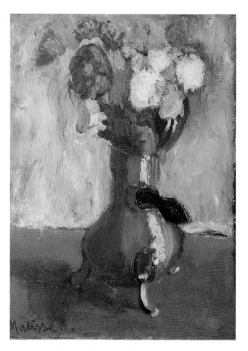

HENRI MATISSE (1869–1954).
Bunch of Flowers in a Chocolate Pot, [1902].
Oil on canvas, 25¼ x 18⅛ in. (64 x 46 cm).

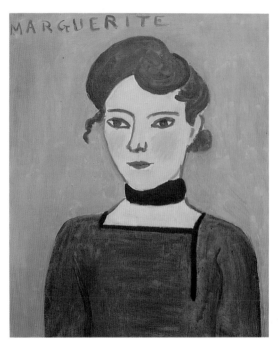

HENRI MATISSE (1869–1954).
Marguerite, 1907.
Oil on canvas, 25¼ x 21⅜ in. (65 x 54 cm).

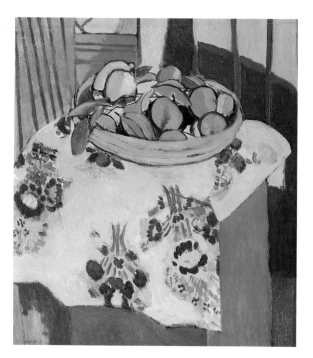

HENRI MATISSE (1869–1954).
Still Life with Oranges, 1912.
Oil on canvas, 37 x 32⅝ in. (94 x 83 cm).

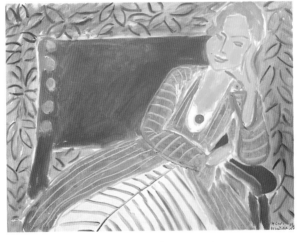

HENRI MATISSE (1869–1954).
Seated Young Girl in a Persian Dress, 1942.
Oil on canvas, 16⅞ x 22 in. (43 x 56 cm).

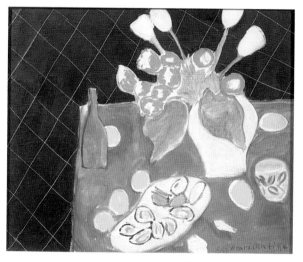

HENRI MATISSE (1869–1954).
Tulips and Oysters on a Black Background, 1943.
Oil on canvas, 24 x 28⅝ in. (61 x 73 cm).

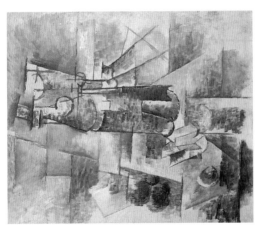

GEORGES BRAQUE (1882–1963).
Still Life with a Bottle, 1910–11.
Oil on canvas, 21⅝ x 18⅛ in. (55 x 46 cm).

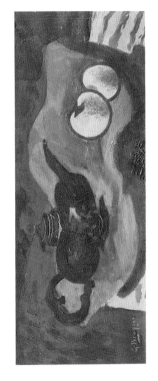

GEORGES BRAQUE (1882–1963).
Teapot and Apples, 1942.
Oil on canvas, 10⅜ x 25⅝ in. (26 x 65 cm).

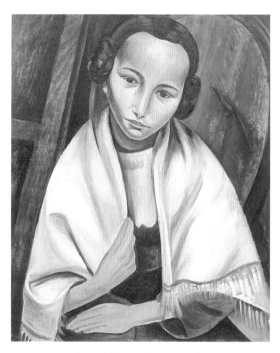

ANDRÉ DERAIN (1880–1954).
Portrait of a Young Girl, 1914.
Oil on canvas, 24 x 19⅝ in. (61 x 50 cm).

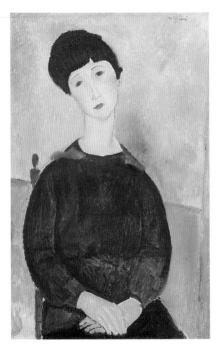

AMEDEO MODIGLIANI (1884–1920).
Young Brunette, Seated, [1918].
Oil on canvas, 36½ x 23⅝ in. (92 x 60 cm).

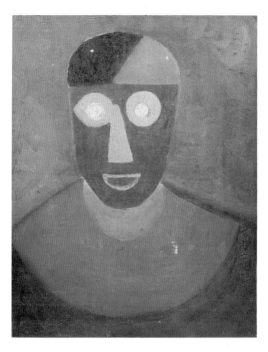

MANUEL ORTIZ DE ZARATE (1886–1946).
Portrait of Picasso, [1920–25].
Oil on panel, 16⅛ x 12⅞ in. (41 x 32.7 cm).

MAX ERNST (1891–1976). *Bird from the Forest,* [1927–28].
Oil on paper pasted on cardboard,
12¼ x 8⅝ in. (31 x 22 cm).

JOAN MIRÓ (1893–1983).
Self-Portrait, 1919.
Oil on canvas, 28⅝ x 23⅝ in. (73 x 60 cm).

JOAN MIRÓ (1893–1983).
Portrait of a Spanish Dancer, 1921.
Oil on canvas, 26 x 22 in. (66 x 56 cm).

BALTHUS (born 1908).
The Children Hubert and Thérèse Blanchard, 1937.
Oil on canvas, 49¼ x 51¼ in. (125 x 130 cm).

INDEX OF ILLUSTRATIONS

Unless otherwise noted, all works are by Picasso.

Acrobat, The, 77

Acrobats: Women Combing Their Hair, 219

Allegory: Young Man, Woman, and Grotesques, 205

Anatomy: Three Women, 260

Angry Owl, 196

Apple, 155

Artist before His Canvas, The, 102

Artist's Dining Room, on rue La Boétie, The, 247

Artist's Living Room on rue La Boétie, The: Jean Cocteau, Olga, Erik Satie, and Clive Bell, 250

Artist's Mother and Sister Embroidering, The, 201

At School: Lola, the Artist's Sister, 198

Baboon and Young, 190

Bacchanalia, 269

Ball Players on the Beach, 71

Balthus, 312

Barefoot Girl, The, 20

Bather (1928), 69

Bather (1931), 169

Bather Opening a Bathing Cabin, 70

Bathers, 49

Bather Seated in a Landscape, or Eurydice (Renoir), 292

Bathers Looking at an Airplane, 55

Bathers Playing Ball, 72

Bather with a Ball, 75

Bearded Man with a Pipe, at a Table, 238

Bearded Man with Crossed Arms, 215

Bird from the Forest (Ernst), 309

Bird in a Cage, 135

Bottle of Anis del Mono and Fruit Bowl with Grapes, 159

Bottle of Bass, Glass, and Newspaper, 158

Bottle of Wine and Dice, 134

Braque, Georges, 304–5

Bullfight (1897–98), 202

Bullfight (1922), 61

Bullfight: The Death of the Female Torero, 85

Bullfight: The Death of the Torero, 86

Bunch of Flowers in a Chocolate Pot (Matisse), 299

Bust of a Bearded Man, 176

Bust of a Man (study for Les Demoiselles d'Avignon), 29

Bust of a Woman, 172

Bust of a Woman (study for Les Demoiselles d'Avignon), 32

Bust of a Woman or a Sailor (study for Les Demoiselles d'Avignon), 30

Bust of a Woman with Striped Hat, 104

Cat, 181

Celestina, 24

Ceremonial "Nevinbumbaau" Headdress (New Hebrides), 275

Cézanne, Paul, 288–91

Chair, The, 192

Chardin, Jean-Baptiste-
Siméon, 284
*Child Playing with a
Truck,* 111
*Children Hubert and
Thérèse Blanchard,
The* (Balthus), 312
Child with Doves, 106
*Composition with
Butterfly,* 147
Composition with Glove,
146
Courbet, Gustave, 285
Crucifixion, The (1930),
78
Crucifixion, The
(September 1932),
258
Crucifixion, The
(October 1932), 259
*Cup with Faun and
Cymbals,* 197
*Death of Casagemas,
The,* 21
Death's Head, 182
Degas, Edgar, 286–87
Derain, André, 306
Ernst, Max, 309
Family at the Seashore,
63
Family of Acrobats, 218
Faun, Horse, and Bird,
265
Figure (1907), 153

Figure (1931), 168
Figure (1935), 178
Figure (for a proposed
monument to
Guillaume
Apollinaire), 165
Figure by the Sea, 262
Figures at the Seashore, 79
Five Bathers (Cézanne),
288
*Frontal Nude with
Raised Arms* (studies
for *Les Demoiselles
d'Avignon*), 222
Gauguin, Paul, 296
Girl Jumping Rope, 186
Glass, 43
*Glass, Newspaper, and
Die,* 138
*Glass, Pipe, Ace of
Clubs, and Die,* 140;
detail, 138
*Glass, Tobacco Pack, and
Ace of Clubs,* 42
Glass and Newspaper,
139
*Glass and Pack of
Tobacco,* 161
Glass and Pipe, 48
*Goat's Skull, Bottle, and
Candle* (1951–53),
191
*Goat's Skull, Bottle, and
Candle* (1952), 110

Grebo Mask (Ivory
Coast), 279
Guitar (1913), 39
Guitar (1924), 162
Guitar (April 29, 1926),
143
Guitar (April 31 [*sic*],
1926), 144
Guitar (May 1926), 145
Guitar (spring 1926,
relief painting on
canvas), 142
Guitar (spring 1926,
relief painting on
panel), 141
*Guitar, Glass, Bottle of
White Brandy,* 132
*Guitar and Bottle of
Bass,* 136
Guitar Player with a Hat,
233
*Hairdo, The, or Woman
Bathing* (Renoir), 293
*Happy Family, The, after
Le Nain,* 47
Head (1913), 131
Head (1928), 164
Head (1931), 167
Head of a Bull
(1931–32), 174
Head of a Bull (1942),
180
Head of a Chamois Goat
(Courbet), 285

314

Head of a Man (1907), 154

Head of a Man (1972), 271

Head of a Woman (1931, plaster), 170

Head of a Woman (1931, plaster and wood), 173

Head of a Woman (1940), 266

Head of a Woman (Fernande) (1906), 151

Head of a Woman (Fernande) (1909), 156

Head of a Woman in Profile, 175

Head of a Woman in Profile (Marie-Thérèse), 171

Head of a Woman Screaming, 212

Head of Harlequin, 133

Houses and Palm Trees, 230

Iberian Bull (n.d.), 281

Iberian Praying Figure (6th–5th c. B.C.), 280

Jacqueline with Crossed Hands, 113

Jester, The, 148

Kiss, The (1925), 67

Kiss, The (1969), 121

Kitchen, The, 108

Kitchen Table and Utensils with Cut of Mutton (Chardin), 284

Landscape (Gauguin), 296

Landscape: Aix Cathedral (Cézanne), 291

Landscape at Juan-les-Pins, 54

Landscape with Two Figures, 35

Large Bather, 74

Large Bather with a Book, 94

Large Nude in a Red Armchair, 73

Large Still Life on a Pedestal Table, 81

Le Nain, Louis, 282

Le Nain brothers, follower of, 283

"Long Live France" (letter to André Salmon), 240

Lullaby, The (Vuillard), 298

Luncheon on the Grass, after Manet (1960), 116

Luncheon on the Grass, after Manet (1961), 117

Madame's Party, The (Degas), 286

Man before a Fireplace, 45

Mandolin and Clarinet, 157

Man Reading a Newspaper, 237

Man with a Guitar, 37

Man with a Mandolin, 36

Man with a Mustache, 41

Man with a Pipe, 40

Man with a Sheep, 183

Man with a Straw Hat and Ice Cream Cone, 103

Marguerite (Matisse), 300

Matisse, Henri, 272, 299–303

Maya with a Doll, 101

Metamorphosis II, 163

Minotaur and Dead Mare in Front of a Grotto Facing a Young Girl with Veil, 263

Minotaur Raping a Woman, 261

Miró, Joan, 310–11

Modigliani, Amedeo, 307

Mother and Child, 33

Mukuyi Mask (Gabon), 277

Musée Picasso (Hôtel Salé, Paris), 6, 15

Notebook 21 of the Jacqueline Picasso "Dation," 270

Nude in a Garden, 88

Nude in Profile with Raised Arms (study for Les Demoiselles d'Avignon), 224

Nude Woman Imploring the Heavens, 211

Nude Woman Sitting in an Armchair, 241

Nude Woman with Raised Arm, 229

Odalisque, after Ingres, 225

Olga in an Armchair, 251

Olga Thinking, 255

Ortiz de Zarate, Manuel, 308

Owl in an Interior, 107

Pages' Games, 109

Painter and Child, 120

Painter and His Model, The (1914), 44

Painter and His Model, The (1926), 68

Paulo as Harlequin, 65; detail, 16

Paulo as Pierrot, 66

Pipes of Pan, The, 64; detail, 2

Portrait of a Man (early 1902), 210

Portrait of a Man (winter 1902–3), 23

Portrait of Apollinaire, 244

Portrait of Apollinaire with Bandaged Head, 245

Portrait of a Spanish Dancer (Miró), 311

Portrait of a Teenager as Pierrot, 254

Portrait of a Woman (Rousseau), 294

Portrait of a Young Girl, 90

Portrait of a Young Girl (Derain), 306

Portrait of Dora Maar (1937), 92

Portrait of Dora Maar (October 1, 1937), 97

Portrait of Françoise, 267

Portrait of Igor Stravinsky, 253

Portrait of Marie-Thérèse (January 6, 1937), 93

Portrait of Marie-Thérèse (December 4, 1937), 99

Portrait of Olga in an Armchair, 46

Portrait of Picasso (Ortiz de Zarate), 308

Pregnant Woman (1949), 185

Pregnant Woman (1950–59), 189

Procession of the Fatted Cow, The, or The Wine Festival (follower of Le Nain brothers), 283

Ram's Skull, 268

Reading the Letter (1899–1900), 206

Reading the Letter (1921), 57

Reclining Nude, 118

Reclining Nude and Man Playing the Guitar, 123

Remains of the Minotaur in Harlequin's Costume, The (study for the curtain of July 14 by Romain Rolland), 264

Renoir, Pierre-Auguste, 292–93

Representatives of Foreign Powers Salute the Republic as a Token of Peace, The (Rousseau), 295

Rest on the Bed, The (Degas), 287

Rider's Halt, The
(Le Nain), 282

Rousseau, Henri,
294–95

Sculptor and His Model,
The, 256

Sculpture (Fragment)
(New Guinea),
276

Sea at L'Estaque, The
(Cézanne), 289

Seated Nude (study for
Les Demoiselles
d'Avignon), 27

Seated Old Man, 122

Seated Woman, 53

Seated Young Girl, 124

Seated Young Girl in a
Persian Dress
(Matisse), 302

Self-Portrait (1901), 22

Self-Portrait (1906), 26

Self-Portrait (1917–19),
246

Self-Portrait (Miró), 310

Seurat, Georges, 297

Shadow, The, 112

Sheet of Studies: Head of
Christ, Seated Old
Woman, Woman in
Profile, and Hand
Holding a Brush, 207

She Goat, The, 187

Silhouette of José Ruiz

(the Artist's Father)
with Raincoat, 203

Sleeping Nude, 84

Sleeping Woman and
Seated Man, 257

Small Boy with a
Crayfish, 105

Small Nude from the
Back with Raised
Arms (study for
Les Demoiselles
d'Avignon), 28

Small Pregnant Woman,
184

Small Seated Nude, 34

Speaker, The, 179

Spring, The, 59

Standing Nude (studies
for Les Demoiselles
d'Avignon), 223

Standing Nude in Profile,
226

Standing Nudes and
Study for a Foot, 228

Still Life: Fish, Skull,
and Ink Bottle, 227

Still Life on a Chest, 50

Still Life on a Table before
an Open Window,
249

Still Life with a Bottle
(Braque), 304

Still Life with Biscuits,
236

Still Life with Bull's
Head, 115

Still Life with Chair
Caning, 38

Still Life with Oranges
(Matisse), 301; detail,
272

Still Life with Pitcher and
Apples, 51

Straw Hat with Blue
Leaves, 91

Studies, 52

Studies for Self-Portraits,
221

Studio at La Californie,
The, 114

Study for a Carnival
Poster, 204

Study for an Acrobat's
Costume in "Parade,"
243

Study for "Evocation," 208

Study for Head of a
Woman (Fernande),
231

Study for "Parade"
Curtain, 242

Study for Pulcinella's
Costume in
"Pulcinella," 252

Study for "The Couple,"
217

Study for "The Death of
Harlequin," 220

Study for "The Embrace," 213

Study for "The Interview," 209

Study for "The Ironing Woman," 216

Study for the Torero's Costume in "The Three-Cornered Hat," 248

Study for "Woman Wearing a Shirt in an Armchair" (fall 1913, gouache and pencil), 235

Study for "Woman Wearing a Shirt in an Armchair" (fall 1913, wash and pencil), 234

Study of a Skirt for "A Sunday on La Grande Jatte" (Seurat), 297

Supplicating Woman, 100

Swimmer, The, 76

Teapot and Apples (Braque), 305

Three Still Lifes, 239

Three Women at the Spring, 58

Tsogho Mask (Gabon), 278

Tulips and Oysters on a Black Background (Matisse), 303

Two Brothers, The, 25

Two Nude Women on the Beach, 96

Two Women Running on the Beach, or The Race, 62

Vase: Woman with a Mantilla, 194

View of the Château Noir (Cézanne), 290

Village Dance, The, 60

Violin (1912), 129

Violin (1913–1914), 137

Violin (1915), 160

Violin and Sheet Music, 130

Violin Player, 232

Vuillard, Edouard, 298

Weeping Woman, 98

Woman Combing Her Hair, 152

Woman in a Garden, 166

Woman in a Red Armchair, 83

Woman Reading, 89

Woman's Head, 56

Woman Sitting before a Window, 95

Woman Throwing a Stone, 80

Woman with a Baby Carriage, 188

Woman with a Mirror, 214

Woman with Candle, Fight Between the Bull and the Horse, 87

Woman with Joined Hands (study for Les Demoiselles d'Avignon), 31

Woman with Leaves, 177

Woman with Outstretched Arms (for a monument at Saint-Hilaire), 193

Woman with Pillow, 119

Woman with Stiletto, or The Death of Marat, 194

Young Brunette, Seated (Modigliani), 307

Young Painter, The, 125